Contents

Introduction

With equipment costs falling and an ever-expanding choice of print media available, there's never been a better time to make digital prints.

Like all new technology, learning how to get the very best out of your digital camera and printer can seem daunting at first. However, as more and more photographers plug into the creative possibilities of inkjet printing, now is the time to take the plunge!

The *Digital Print Styles Recipe Book* assumes little or no prior knowledge of the printing process. Instead, each stage of the process is carefully dissected and explained in jargon-free terms.

The very best prints start their life as top-quality image files that are accurately exposed "in-camera," then carefully prepared before printing. Yet, with so many software products available it can be difficult to know which is the best route to take.

To start you off in the right direction, Chapter 1, "Hardware," identifies the essential equipment you need and provides unbiased advice on practical solutions to fit all budgets. Covering computer types, performance, and storage, it also serves as a straightforward guide to setting up your own workstation properly.

To whet your creative appetite, the second chapter, "Print Media," will introduce you to the wide range of papers, fabric, and formats available to print with. With hundreds of different paper types, colors, and surface textures, sourcing the right media for your project can be a time-consuming process. To solve this, a recommended paper type is included with each practical project.

If you're unfamiliar with the underlying concepts behind digital data, then the "Software Basics" and "Printing" chapters provide you with all the underpinning knowledge you need to get up to speed with using Adobe Photoshop Elements and generic printer applications.

Once you've developed the confidence to experiment with paper types, sizes, and shapes, the next chapters, "Color Styles," "Mono Styles," and "Toning," show you how to make your images more eye-catching. With simple but effective recipes available in Photoshop Elements and suggested paper types, your images may never look the same again!

Unlike conventional photo prints made in the darkroom, digital prints can sometimes lack a personal touch. In Chapters 8, 9, and 10—"Edge Styles," "Custom Prints," and "Creative Media"—plenty of alternatives are illustrated, so you can add your own personal signature to your work, making it stand out from the crowd.

"Finishing Touches," "Print Services," and "Reference," the final three chapters, provide essential information on mounting and presenting your work, and finding professional services and suppliers for making one-off or special-sized output.

1

Hardware

Computer workstation

Nowadays, even a budget home computer is fast enough to run a photo-imaging application and store your image files.

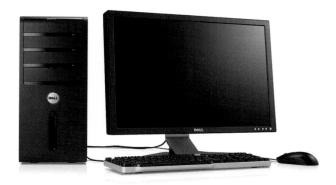

Windows PC workstation

Software such as Adobe Photoshop Elements is primarily designed for the home PC user running a Windows operating system, like this Dell workstation, shown left. When buying a new workstation, it's a much better idea to use your budget for extra RAM and a high-quality monitor, than to spend it all on a computer with the fastest processor.

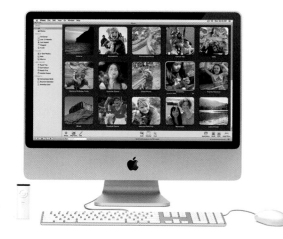

All-in-one computer

The iMac from Apple, shown right, is an excellent option if you have a limited desktop workspace or prefer to keep technology at arm's length. Latest Intel-chip iMacs can run the Windows operating system too, and are available with either 20- or 24-inch screens. iMacs are very portable and offer a range of ports and connection sockets within easy reach.

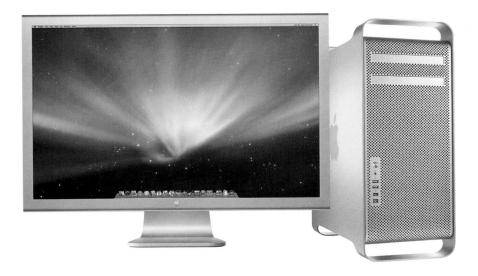

Professional Apple workstation

For the ultimate in color control, a professional workstation such as the Apple G5, shown above, is second to none. With this kind of setup, you can use a wide range of monitors and install additional memory and storage components as your skills and demands increase.

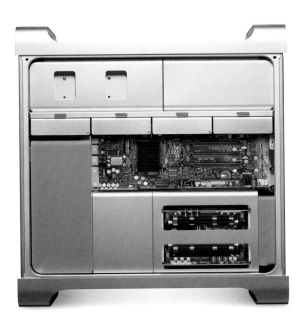

Upgrading and customizing

An Apple G5 computer, shown left, provides easy access for building a custom computer workstation. Installing extra memory or additional hard drives is a straightforward process for confident do-it-yourself enthusiasts without the need for specialist tools.

Monitors

The display is the most important part of your workstation, and provides the only visual check between your files and printout.

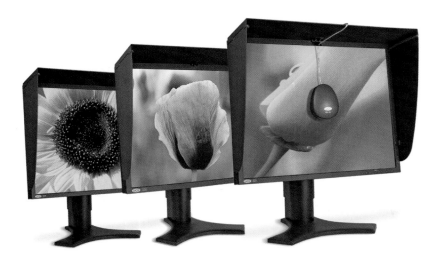

Flat-panel monitors

Although it is possible to buy cheap flat-panel monitors, they will have fewer saturated colors and can be darker than professional products. Aim for a model with a contrast ratio of 600:1 or more and a brightness of 300 cd/m2 or more, like the LaCie shown above.

Monitor hoods and screens

Every display is compromised by ambient room light and distracting background colors. However, viewing conditions are easily improved by adding a wraparound hood, as shown above, or a low-tech screen in a neutral color, as shown right.

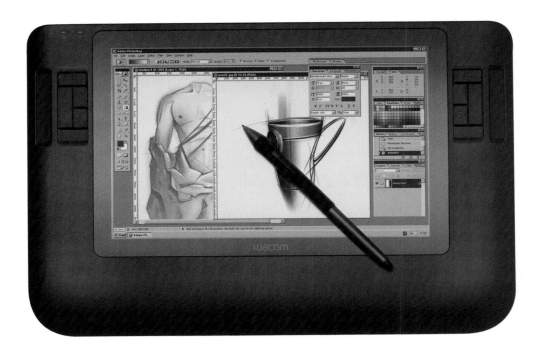

Touch-sensitive screens

The innovative Cintiq screens by Wacom, as shown above, can be drawn on directly with the use of a stylus rather than a mouse. The Cintiq can also be placed flat on a desk or your knee and worked on like a sheet of paper or a sketchpad.

Laptop screens

Recent laptops have LED screens, which are much better at displaying color than their predecessors. When printing from laptops, it's essential that you set the hinged lid to the manufacturer's recommended viewing angle, to preserve good-quality color and contrast.

Monitor calibration

Poor positioning of the monitor and a lack of color calibration are at the root of most digital printing problems.

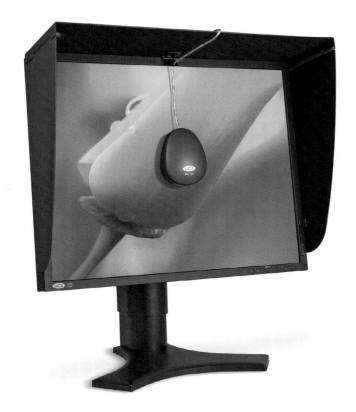

Why calibration is essential

Straight out of the box, a brand-new monitor will certainly switch on, but it will not yet be ready to print from. Calibration is the process by which a monitor is set up to display a uniform brightness and contrast, together with a neutral color appearance. There's no sense trying to do this by eye or by using the hardware dials. A much better approach is to use a monitor profiling device, as shown above. The profiler is plugged into your PC and automatically corrects the current monitor settings before creating and installing a permanent settings file in your operating system. This tiny file, called a profile, is then used as the default setting each time your PC is switched on, or if you accidentally change your viewing conditions with the hardware dials.

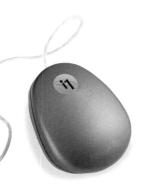

The i1 Display 2
A low-cost monitor profiler, such as the X-Rite i1, shown left, will easily pay for itself by reducing ink and paper waste.

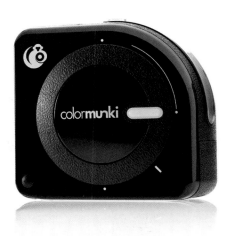

Dual print and monitor profiler
The X-Rite ColorMunki Photo, shown right, can also be used to calibrate LCD projectors and to produce profiles for printing onto special papers.

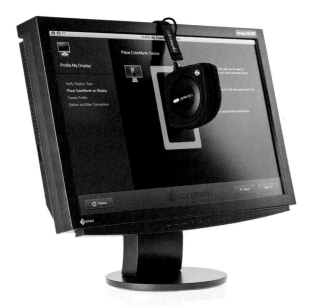

How the profiler works
Each profiling device, such as the ColorMunki Photo shown left, is operated through a step-by-step application. No experience of color calibration is required, as the device makes all the assessments for you. Once placed on the surface of the monitor, the profiler is fed a succession of colored patches, taking about ten minutes from start to finish. Many photographers re-profile their monitors every three months to ensure an accurate color environment.

Digital cameras

Despite the many models available, digital cameras are simple to rank. The more pixels they capture, the bigger print you can make.

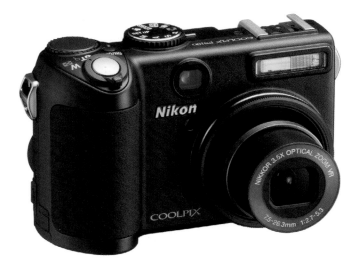

Advanced compact camera
The Nikon Coolpix P5100, shown left, is a typical mid-price compact camera with a clip-on lens set. This kind of compact has a tiny viewfinder window so you can frame your subjects without using the power-hungry rear LCD preview. Advanced compacts will create image files big enough to make 13"×19" inkjet prints and are ideal starter cameras for budding photographers.

Pocket-sized compact camera
Designed with convenience and portability in mind, this kind of camera will create image files large enough to make photo-quality letter-sized inkjet prints. With fewer creative controls compared to advanced compacts, the Nikon Coolpix S210, shown right, is an ideal second camera to keep in your kitbag.

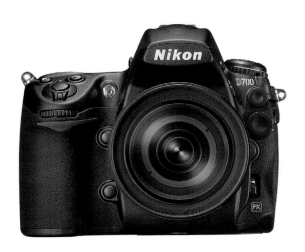

Digital single lens reflex (DSLR)

The finest-quality images are created when using a DSLR camera, such as the Nikon D700, shown left. This kind of camera is supported by a wide range of interchangeable lenses, flashguns, and capture software, giving you all the tools to shoot technically complex subjects. DSLRs are built to withstand repeated use and are ergonomically designed to make handling easy. The most important feature of a DSLR is the ability to precisely frame your subject through the lens, rather than through a separate viewfinder window or a rear LCD screen.

Advanced controls and settings

DSLRs enable you to choose from a wide range of settings to meet demanding shooting conditions. With the ability to focus precisely on your selected subject and preview your depth of field, you can exert the most creative control with this type of camera. Most DSLRs can capture in the RAW file format, now acknowledged to be the best way of preserving image quality, and can accept large-capacity storage cards, too. A DSLR such as the Nikon D700, shown right, creates enough pixels to produce a gigantic 21"×14" inkjet print.

Location essentials

Excellent print quality is always linked to good shooting technique and can be further improved with the addition of a few extra tools in your kitbag.

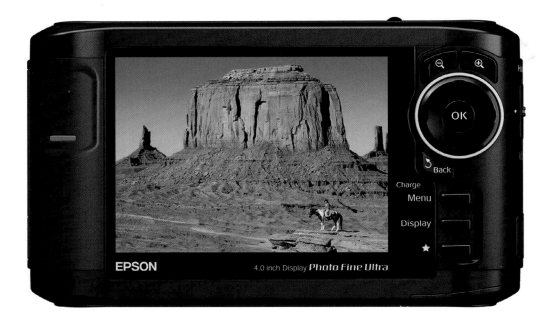

Combined viewer/data store

A good alternative to carrying a heavy laptop on your photo shoots is a purpose-built viewer, such as the Epson P-5000 shown above. A good-quality viewer reads image files stored on a connected camera or inserted memory card, so you can preview images on location. Bigger than a camera's rear LCD screen, a specialist viewer can display all 16.7 million colors in your image file, giving you a better indication of exposure accuracy and providing a more comfortable way to edit down a large selection of images.

The Epson P-5000 can also act as a portable data store, so you can transfer image files off your camera memory card to free up space while away from your workstation. The battery-operated viewer is an essential gadget for travel photographers and can also be linked to most direct printing devices through a standard USB lead and PictBridge software. The viewer will also support most common audio and video file formats and provide playback facilities on location.

Spare memory cards

Camera memory cards can easily become corrupted or stop working without notice. It's essential to buy good-quality media, such as Lexar, shown left, and carry at least one spare card in your kitbag, preferably in a protective plastic box.

Waterproof camera bag

All photographic equipment nowadays contains some form of computer component that is vulnerable to physical damage, moisture, and exposure to excessive magnetic fields. A good waterproof bag, such as a Tenba, shown right, provides proper protection for a camera kit and laptop.

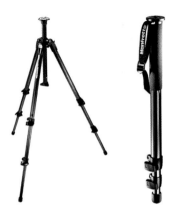

Camera supports

The technique for making pin-sharp prints starts by holding your camera steady. Every photographer, young or old, makes slight body movements at the point of exposure, which can cause blurry end results. Supporting your camera with a tripod (or if you want to avoid interrupting your flow, a monopod) is a smart idea. These two products from Manfrotto (shown left) are lightweight, easy to carry, and quick to spring into action.

Printers

With so many different models on the market, it can be difficult to decide which printer is the best for your workstation.

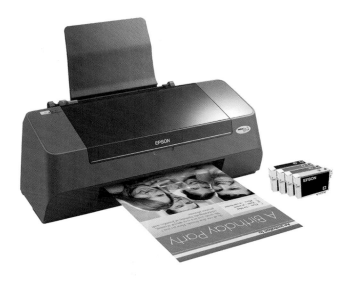

Four-color inkjet

At the bottom of the photo-quality scale is the budget four-color inkjet, such as this Epson shown left. With only three colors—cyan, magenta, yellow, plus black—this kind of printer can't produce subtle photographic-quality results. Budget printers will usually employ dye-based inks, which are prone to fading in the short term.

Photo-quality inkjet

At the top of the range, this kind of device uses six or more separate ink cartridges to create prints that are indistinguishable from conventional photographs. The Epson Stylus Photo R1800 (shown right) uses eight colored inks, including light magenta, light cyan, and light black, to achieve richer tonal gradation. To get the very best out of different paper types, the R1800 can also be used with a choice of matte or photo black inks. This type of printer uses lightfast pigment ink, good for about 80 years without fading.

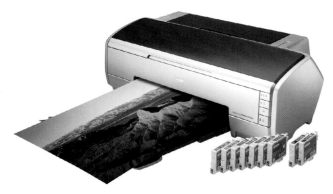

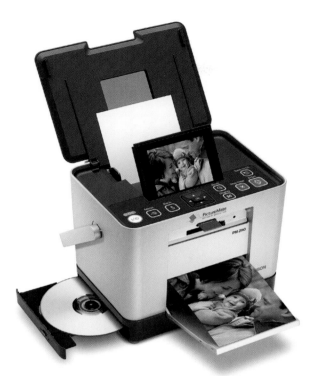

Small-format direct printer

A very useful addition to your kit, the direct printer is capable of making 6"×4" inch prints, direct from your camera, without needing to be attached to a computer. Fitted with a universal memory card slot, USB port, and Bluetooth, Epson's PictureMate 290, shown left, also has an LCD preview screen so you can check and make basic adjustments before printing. The device provides an internal CD-RW drive, so you can also make a backup disc of your files. Small-format printers use cartridge-style sets of ink, rather than individual colors, and with such a small footprint, are ideal for taking on vacation.

Battery-operated portable printer

The Polaroid PoGo, shown right, is a portable printer that makes 2"×3" instant prints direct from Bluetooth-enabled camera phones or USB-connected cameras.

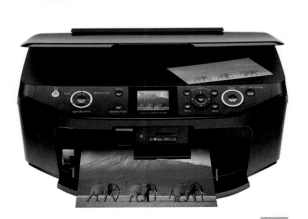

All-in-ones

Unlike the small-format printer, the all-in-one device can scan, print, and do basic photocopying. Fitted with a card reader and LCD preview screen, this kind of printer is very convenient, but won't produce the same fine output compared with a photo-quality inkjet printer. Print size is usually restricted, too.

Photo-quality printers

With lightfast inks and sophisticated driver software, the photo-quality inkjet printer can produce eye-catching results.

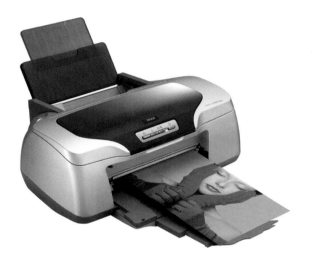

Letter-sized pigment ink printer

The compact letter-sized printer, such as the Epson Stylus Photo 800, shown left, provides top-quality results on a wide range of printing media. The device uses an innovative eight-color inkset, including a new blue and red cartridge, to produce richly saturated colors. Priced at around half the cost of a 13" model, this is an ideal printer to start out with.

17" pigment ink pro printer

At the top of the range is the sturdy 17" printer, such as the Epson Stylus Pro 4800, shown right. Fitted with a permanent paper roll feeder, internal guillotine, and high-capacity ink cartridges, this kind of device is used by most photo professionals and design studios. Despite costing five times as much as a letter-sized printer, larger devices are more economical to run in the long term, with ink and paper cheaper to buy in larger volumes.

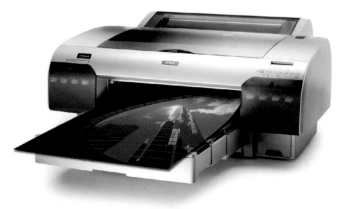

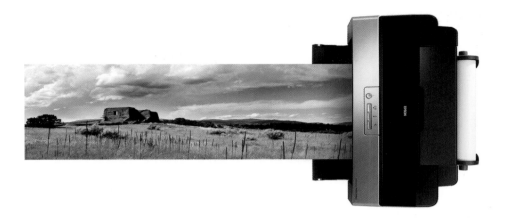

13" pigment ink printer

An excellent mid-price option is the Epson Stylus Photo R2880. The device prints at the highest resolution to produce photo-quality prints on a wide range of media, including canvas, cotton, and roll paper, as shown above. This type of printer also provides both software and special ink for making high-quality monochrome prints, as shown below. Producing prints free from color casts and as impressive as conventional black-and-white prints made in the darkroom, this model is ideal for making exhibition-quality digital prints to sell.

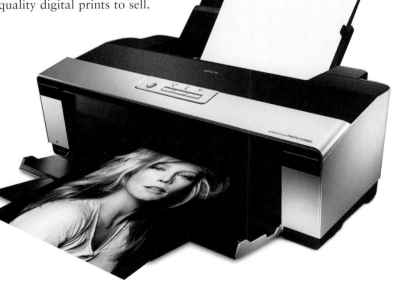

Storage peripherals

Image files can take up a lot of storage space on your computer's hard drive, so it's a good idea to have a safety net.

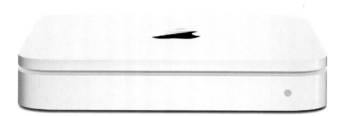

Wireless backup

Data is easily lost or corrupted through faulty disks and drives. Apple's Time Capsule is a combined external hard drive and Wi-Fi base station, allowing you to back up your data easily without wires or complicated ports on your PC.

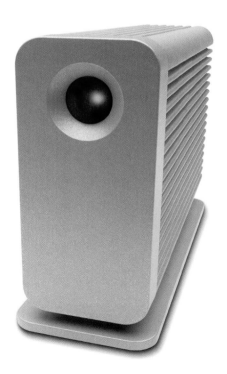

High-capacity desktop hard drive

An easy way of upgrading the available storage space on your workstation is to buy an external hard drive. The LaCie model, shown right, provides a gigantic extra 500GB, which should be more than enough to hold your entire image library in one convenient place. Although more expensive than an internal hard drive with the same capacity, desktop drives are easily connected through the computer's USB or FireWire ports. Drives such as these offer a convenient way to transport large volumes of images between different workstations, providing the unit is carefully handled in transit and connecting plugs are not forcibly inserted.

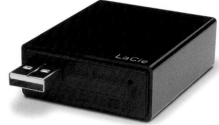

USB keys or pen drives

With available capacities now in excess of 30GB, the humble USB pen drive can provide a very useful backup and portable storage facility. The LaCie Little Disk, shown above, draws power from the host PC, and with no moving internal parts, is much less vulnerable to physical damage caused while in transit.

Ports and connecting cables

Most storage peripherals are designed to transfer data at high speed using either USB or FireWire connections, identified by the symbols shown below. Some devices, like the LaCie desktop hard drive, shown right, can use both. Windows PCs are rarely fitted with the FireWire connector (also known as IEEE 1394), but Apple computers usually have both.

FireWire

2

Print media

Ink essentials

The more ink colors your inkjet printer can use, the better and brighter your results will be.

Four-color inkset
Most budget inkjet brands employ the basic CMYK inkset—Cyan, Magenta, Yellow, and Black (to avoid confusion with Blue)—usually in a single cartridge. In use, it's impossible to achieve subtle colors, especially flesh tones, with such a mix.

Primary color inkset
By adding two extra primary colors to the CMYK set, like blue and red, a broader range of bright colors can be printed.

Canon PIXMA Pro wide-gamut inksets
This ten-color ink pack, including green and orange, is used in top-of-the-line Canon PIXMA Pro inkjet printers and offers a wide range of color.

Inkset with three shades of black
This eight-color ink pack is found on most large-format inkjets. In addition to lighter versions of both cyan and magenta, the pack also includes three shades of black for making subtle black-and-white prints.

Third-party special inks

Many photographers have a second inkjet printer charged with special inks for black-and-white prints, as shown above. Lyson and Inkjetmall.com both make a four-color black inkset for producing warm-toned prints.

Fading caused by dye-based inks

The best inks are made with lightfast pigments rather than dye. Cheaper inksets, especially third-party brands, use dyes that are prone to fading when prints are displayed in normal daylight conditions, as shown left. Never cut costs on ink, as you'll need to keep reprinting.

Paper essentials

Before the invention of the inkjet, photo prints were glossy or luster. Now you can output onto canvas, cotton rag, and artist's paper.

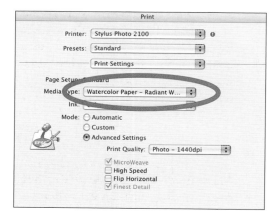

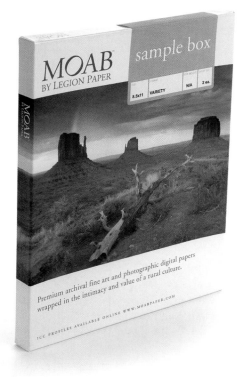

Select the correct media type

To ensure the right amount of ink is sprayed onto your paper, it's essential to select the correct media type in your printer software dialog. Purpose-made inkjet paper has a fine powder coating to hold in place tiny ink droplets. Uncoated art papers can only accept a few large ink dots before they start to spread and merge into one another, resulting in a muddy, unsharp print.

Two kinds of black ink

Most inkjet printers can be used with two different kinds of black ink: Photo Black (PK) or Matte Black (MK). Photo Black is best used with glossy, shiny papers and Matte Black with smoother media, including cotton papers.

Sample packs

A great way to experiment with different types of inkjet paper is to buy a sample pack, such as the fine art papers from Moab, shown above. Packs such as these include a couple of sheets of each variety of weight, color, and texture. Like all third-party papers, best results are achieved when printed out using paper profiles.

Glossy papers

This kind of media will reproduce the brightest colors and the richest blacks when used with the correct printer software settings. To get the best out of this media, it's essential to use a Photo Black ink cartridge to avoid the appearance of mottled drying marks in the shadow areas of the image. Best-quality glossy paper needs a little drying time, so don't judge color balance while the paper is still wet.

Matte and coated cotton papers

Matte paper has the same kind of fine inkjet coating as glossy, but without the varnish layer on the surface. Matte papers are capable of displaying ultra-sharp details, but do so with slightly less vivid colors compared to glossy media. Archival cotton papers also add an extra tactile dimension to your prints.

Cream-based papers

No printer in the world uses white ink. Instead, the bright highlights in your image are created by "holes" in the ink, which let the paper underneath show through. When a cream or soft white paper is used, highlights take on this new color to add a vintage or period feel to your work.

Paper sizes

Good-quality paper doesn't come cheap, so it's best to plan a printing project well in advance so you can buy your material in bulk.

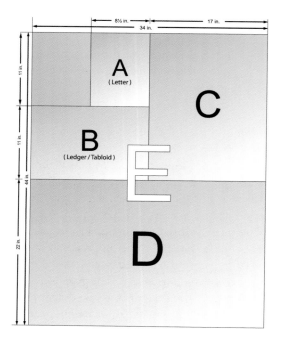

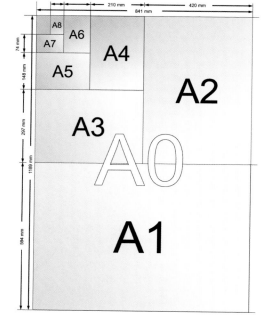

ANSI and International paper sizes

In the United States, paper sizes are standardized by the ANSI scale measured in inches, as shown above left. Internationally, however, a different size scale is used, measured in millimeters, shown above right. In simple terms, the ANSI sizes are shorter and slightly wider than A-size equivalents, but both follow the same convention of doubling or halving as the size goes up or down. Most printer software is preset to work with both systems and also custom-sized shapes that you invent and save in your printer software.

Edge-to-edge printing

Many inkjet printers don't offer the facility to make an edge-to-edge print, instead leaving thin white borders around the edge. However, to combat this, it is possible to buy oversize sheets of paper, identified by the word "Super" in front of the size code, such as Super A3. These slightly larger sheets enable you to make bigger prints, which you can then trim into an edge-to-edge style. Adobe Photoshop Elements software can include cropping marks on your prints, so you don't have to guess where to cut.

Inkjet paper cards and specials

Many paper manufacturers now make printable cards and envelopes, so you can turn your photographs into salable items. Prefolded and scored cards are a good option and give your cards or envelopes a professional look. These cards from Moab, shown right, come with printable envelopes, too.

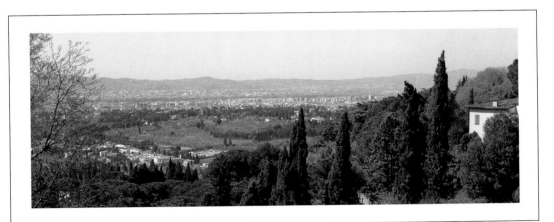

Roll paper

The most economical paper format is the roll, available in 4", 8.5", 13", and 17" (and beyond) widths. When used with a printer equipped with an internal cutter, roll paper is a very efficient way of making lots of prints at the same time. Once set up, there's no need to worry about paper feed jams, and you keep handling to a minimum as well. Roll paper also allows you to experiment with different print shapes, including panoramic, as shown below.

Textured media

To make your print really tactile, consider using a paper with a laid, bond, or watercolor texture.

Give your print the handmade look
In addition to using different paper colors, it's now possible to output your work onto tactile media. There are two types of paper to consider: the purpose-made textured inkjet and the handmade papers found in your local art store.

Purpose-made inkjet papers produce sharper end results with brighter colors, but handmade paper made with real pressed flowers and leaves, as shown above and right, can add a further dimension to your work. Laid or Bond writing paper can also be effective when used with the Plain Paper setting in your printer software, as shown far right.

Printable discs and covers

You can personalize collections of your own images on printable CDs and DVD discs and make eye-catching cover prints, too.

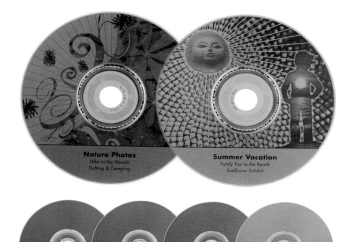

How to print on discs

All printable discs are supplied with free or downloadable templates to use in Photoshop Elements, so you can arrange your artwork to fit inside the circular document shape.

Precolored media

In addition to straight white colored discs, you can also use precolored discs such as these examples, shown left, from LaCie. With this kind of media, you can create an effective design using black ink only.

Special printing tray

Certain inkjet printers are able to print directly onto printable discs with the addition of a tray, as shown right. The discs are usually covered with a special coating, which accepts the ink without smudging. Once the tray has been slotted in, the printer software detects it and provides specially prepared settings to make the print successful.

Disc case prints

You can further personalize your image collections by making insert prints for disc cases. Shown left is a simple cover image printed to slip into a CD case. If you use discs to archive your work in a safe place, it can be very difficult to know what's on the disc. An easy way around this is to make a contact print, shown below, to show the contents. The exact size of the disc case can be set as a Custom Page size, so when the print is trimmed, it fits exactly inside the case. See how to do this on page 154.

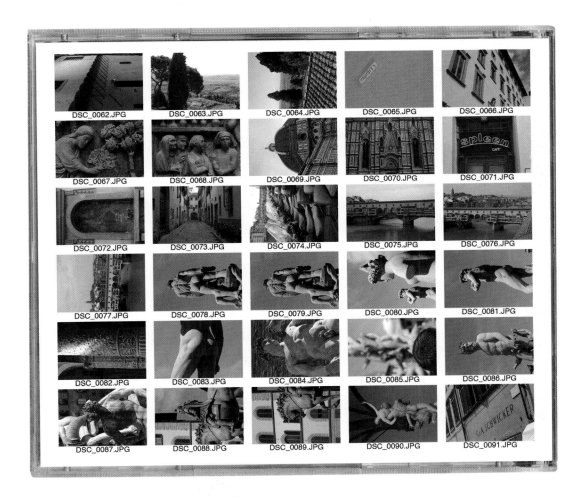

Art paper

Tactile, textured, and steeped in history, art paper can give your images a compelling appearance.

Ink and absorbency

Art papers are designed for a number of different uses, and this is reflected in their manufacture. The best art papers are made from cotton fibers rather than the cheaper wood pulp used for commercial paper stock. Cotton fibers produce a material that provides a greater physical strength in large sheet sizes and a much longer lifespan.

Many of the better papers are prepared under strict process guidelines, designed to avoid the use of bleaches and other chemical agents that would compromise the archival properties of the end product. Such products are deemed "archival" and, although priced at a premium, will provide a stable and long-lasting support for your print.

In addition to chemical agents, many art papers are coated with a transparent substance called size. This invisible topcoat is used to provide a semi-permeable surface and to prevent fine brushmarks from bleeding into one another, as happens with blotting paper. However, many sized papers are not good at absorbing ink droplets, and art photographers prefer to use unsized papers to print with.

The key to using art papers is patience! Most work best when used with Plain paper settings in the printer software, and most can't accept the finest of ink dots—720 dots per inch is the typical choice. A print made with higher-quality settings usually looks muddy, dark, and unsharp.

Benefits

Papers such as Moenkopi have a textured surface, irregular edges, and unusual composition. For the ultimate feel of an artist's limited edition print, consider using a deckle-edged paper—one made with a deliberate torn edge along one or more sides. The flexibility of cotton and other natural fabrics also allows the use of an embossing stamp, great for enhancing the unique status of the print.

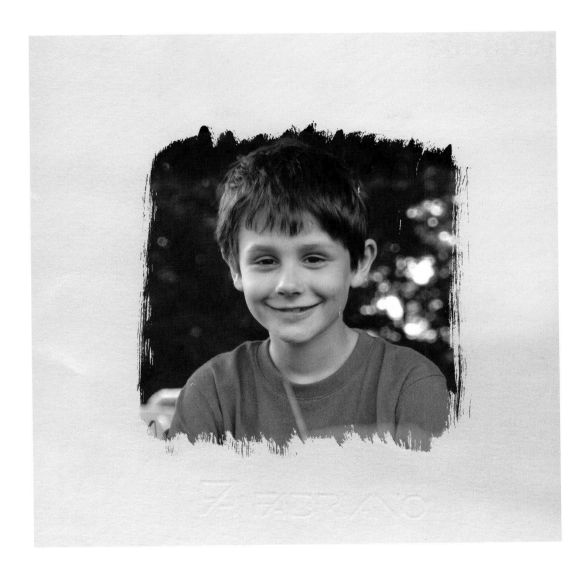

Ink, absorbency, and paper

Art papers, such as the Fabriano paper used above, produce a softer end result compared to bright white papers. Photographic images made on this kind of paper will inevitably lose some sharpness due to ink dots merging into one another, but this softer effect can be very effective, especially for portraits.

Inkjet book kits

A great way to make a family photograph album is to use a do-it-yourself inkjet book kit.

Loose-leaf paper and binders

Getting your photographs assembled into an album can be costly and inflexible once the final selection has been made. A loose-leaf inkjet kit solves both of these problems and provides a simple way of making your own album at home. Most of the major inkjet paper manufacturers sell pre-punched inkjet paper, like the example shown above from Moab. Loose-leaf papers are often coated on both sides, so you can print two images on a single sheet and double the capacity of your album in one stroke.

The main advantage of this system is that you can easily add extra pages or edit the contents of your album over time. Most binders, like the example shown above, use simple screw posts to hold the pages in place, which can easily be unscrewed to accommodate different sheets. Although post books never fully open out like a stitched book, they provide good value for the money.

Designing your album

Inkjet books offer a great way of turning your photographs of a special event or vacation into a more usable format. This example, shown right, was made at the end of a family vacation, by using Photoshop Elements and a simple inkjet book kit.

Unlike photobooks made through a digital on-demand service such as Lulu.com, an inkjet book's photos can potentially be the same quality as individual inkjet prints and will therefore show greater detail in many more colors.

Most inkjet book pages need to be treated as Custom Size sheets of media, but this is easily configured in your printer software as a new size. Once completed, the Custom Size can be reused with each subsequent print.

Shown opposite are three double-page spreads from a vacation book, made with double-sided inkjet paper.

TUSCANY
2008

Printable fabrics

Purpose-made inkjet canvas is a great media to use for turning your images into artwork to display in your home.

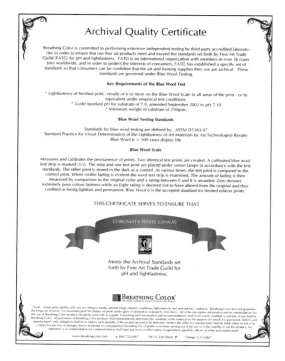

Choosing your media

Although it is possible to buy cut sheets of precoated inkjet canvas, you'll get better value buying it on a roll, as shown above. Like all professional media, best results are achieved when a profile is used rather than generic software settings. It's also important to check the maximum media thickness of your printer before purchasing, as canvas is much thicker than heavyweight papers. Roll-fed canvas should only be cut manually—using scissors—rather than the printer's built-in rotary cutter. Ensure the auto-cut option is switched off before printing.

Selling your canvas prints

Better-quality coated canvas, such as the Breathing Color range, is prepared in strict archival quality conditions. If you intend to sell your canvas prints, plan your production carefully, so the final prints don't fade because you used poor-grade materials.

To help promote your sales, Breathing Color provides a certificate of archival quality, shown above, to reassure potential purchasers concerned about the lifespan of digital prints.

3

Software Basics

Photoshop Elements essentials

The editing package with the best value offers a comprehensive set of tools for great-quality prints.

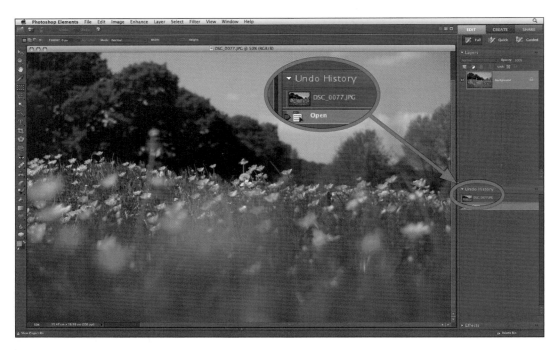

The Desktop interface

Photoshop Elements is jam-packed with features and functions, providing all the tools you need to prepare your files for printout. When first launched, the application is designed to fill the entire desktop, as shown above, to make it simpler to use.

As you grow in confidence, you can customize the Desktop's appearance by dragging new items, such as Layers, Undo History, and Effects, into the right-hand pane.

Using the Undo History feature

If you are new to photo editing, then the Undo History function is worth using at all times. Each time you choose a command, the Undo History records your activity with a simple description in the Undo History palette, shown circled above. If you make five edits to your image, there will be five Undo History records (called states) that you can click on to reverse those edits.

By default the Undo History function is set to record the last 20 commands, but they are not saved when the image file is closed.

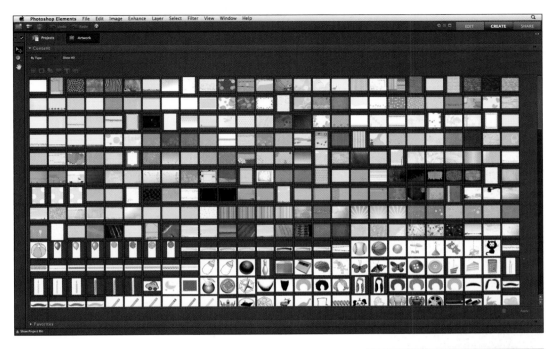

Using Elements' free content

To complement your own images, Photoshop Elements is also bundled with plenty of free templates, clip art, and textures that you can incorporate into your designs. Shown above is the extensive content, located under the Create > Artwork section, which includes frames, patterns, and themes that can be merged into a print project without the need to scan an original.

Using the autorun projects

Hidden inside the Create section are many print projects, shown right, that operate on autorun. While not providing a full structure for a document, these projects will offer a number of inspiring ideas.

Using the Full workspace

Photoshop Elements provides an advanced mode for organizing your desktop so you can edit your projects with maximum control.

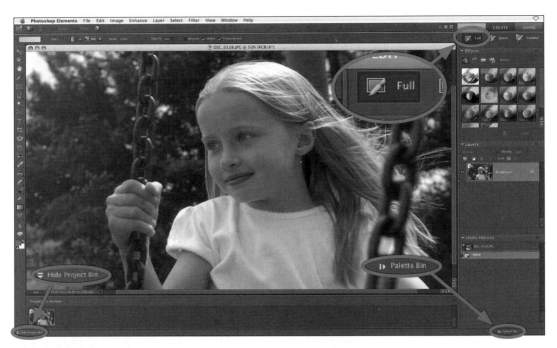

Using the Full workspace

Aimed at more confident users of Photoshop Elements, the Full workspace is easily set by clicking on the Full button, as shown above. In this workspace mode, all the menu-driven tools are made available at the top of your screen, together with the most frequently used palettes docked in the Palette Bin at the right-hand edge of your desktop.

Shown above are both the Effects and Layers palettes, the default palettes that appear in the Palette Bin on first use.

Set at the base of the desktop is the Project Box, where images currently in use are shown as a thumbnails, so you can switch between projects easily. You can use the Project Box to hold your files while you switch workspace modes.

Both the Project Box and the Palette Bin can be temporarily hidden to give you more room on the desktop to work on your images. To hide or unhide the panels, simply click the tiny icons, as shown above.

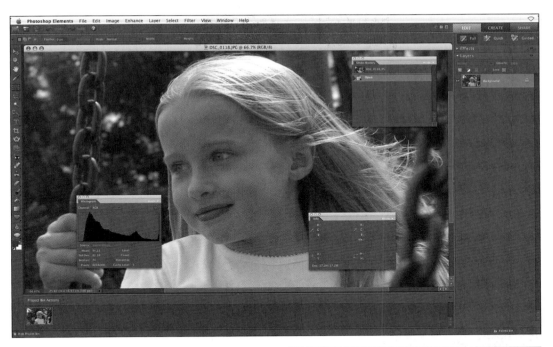

Organizing your work

Like the professional version of Photoshop, Elements' Full workspace provides a complete toolbox on the left-hand side of the desktop, so you can choose the tools you need for a specific task.

In the Full workspace, no help or step-by-step tips are provided, but you can easily switch over to either the Quick or Guided workspace mode (see pages 50–51) for extra assistance, and then switch back again.

In addition to this basic workspace, you can load extra palettes onto your desktop, as shown above, by using the Window menu. Although this offers you more control, it does clutter up your work area and makes less space available to see your image. A much better idea is to dock these extra palettes in the Palette Bin.

Adding extras to the Palette Bin

Choose a new palette from the Window menu and once it's on your desktop, simply drag its name tab over the Full button in the Palette Bin, as shown above. You can easily expand and collapse the content of a palette by clicking on the tiny triangle found to the left of its name tab.

Using the assisted workspaces

The Quick and Guided workspaces are ideal options for those in a hurry or for first-timers who need a helping hand.

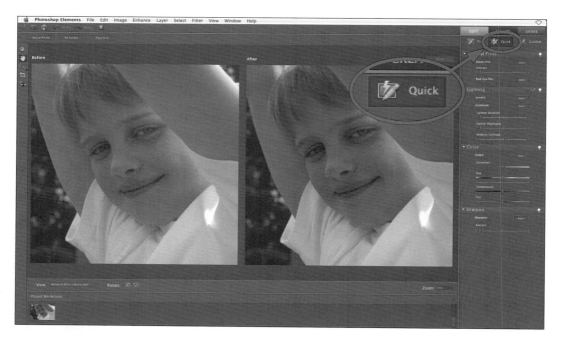

The Quick workspace

This useful option provides several welcome additional features, but also locks access to the full toolbox. The Quick workspace enables you to swiftly edit your images using a range of no-nonsense tools displayed in the Palette Bin, as shown above.

Using a selection of tools taken from the Enhance menu, but conveniently arranged in a single panel, Quick is a fast way to implement your edits if you want to produce an acceptable result without the need for maximum quality.

Viewing before and after

The best feature of the Quick workspace is the handy before-and-after viewing mode, as shown above. As its name suggests, it's used to reference your editing against the starting point, so you can see how far you've improved your original.

The workspace can be split either vertically or horizontally, and you can zoom in and out to check on sharpening edits. There's also a useful Reset button, so you can cancel your Quick edits and return to your starting point.

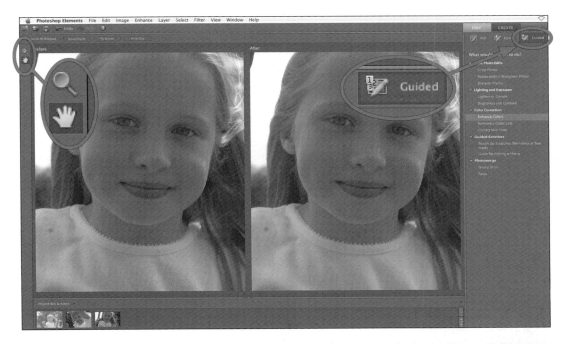

The Guided workspace

The third option is the Guided workspace, shown above, which provides clearly written explanations alongside each tool and control slider. The Guided workspace can also be used in a before-and-after viewing mode, but is most useful at describing the likely results of an edit before you actually do it.

Like the Quick mode, the Guided workspace provides a range of commonly used tools for adjusting image contrast, tone, color balance, and saturation. The Guided selection also contains handy tools for fixing skin tone, blemishes, and other likely faults resulting from shooting portraits.

At the left-hand edge of the desktop, the toolbox is further reduced to showing just the Move and Zoom tools, so you can navigate your way around the image.

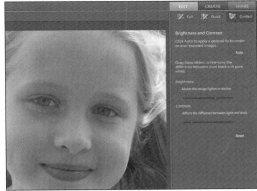

Using the Guided controls

Most of the controls have an Auto function alongside the main adjustable sliders, with a Reset button if you go too far. The Brightness and Contrast controls, as shown above, provide a simple way of correcting minor Exposure errors.

Nondestructive workflow

You can easily maintain maximum image quality throughout shooting, editing, and printing, providing you follow a few simple rules.

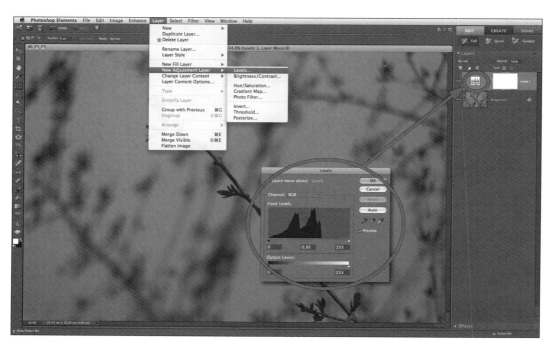

Editing with adjustment layers

An alternative method of editing your files is to use the Layer > New Adjustment Layer command. Adjustment layers work by "floating" your command or setting over the background layer, so it's never embedded in the original file. Instead of stacking multiple commands on top of each other (and generally destroying the quality of your image), adjustment layers help you hold your edits in a state of permanent flux, meaning you can return and change your original decision at any time in the future.

How they work

After you have applied your initial settings in the dialog box and clicked OK, a tiny icon appears on the left end of your layer, as circled above. You can call up the dialog again by simply clicking this icon. When the dialog reappears (in this example, the Levels dialog) the sliders are in exactly the same place you left them. To change your edit, simply move the sliders again, then click OK. If you save your file in the Photoshop (PSD) format, adjustment layers are saved too.

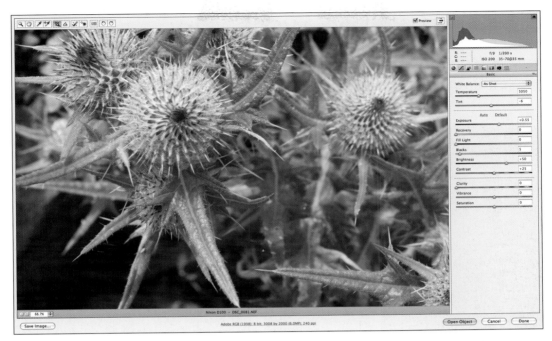

Shooting in the RAW file format

RAW files produce the very highest quality printouts and are central to every professional photographer's workflow. Essentially, RAW files are saved and stored without being modified by the camera's onboard software. Unlike JPEG or TIFF files, no camera settings are embedded in RAW files, but they are at least ten times the size in data terms. This increase in data size means that fewer images can be stored on your camera memory card compared to JPEGs and will also fill up your computer's hard drive quickly.

Best of all, none of your editing changes are ever embedded in your orginal RAW file. Instead, the settings are saved in an invisible sidecar file, which is interpreted by the image editors, such as the Camera Raw plug-in, each time the file is opened. You can never overwrite a RAW file.

Using the Camera Raw plug-in

Photoshop Elements can't edit RAW files directly, but will automatically open your chosen RAW file in the Camera Raw plug-in, as shown above. This free plug-in is available from the Adobe Web site. Camera Raw works by essentially allowing you to edit with camera type settings such as White Balance, Contrast, and Exposure, producing a much better end result than shooting with JPEGs. Once you edit the file, you can then open it in Elements and print it.

Getting the Camera Raw plug-in

If you have a new camera, it may not be supported by an older plug-in, so you'll need to download the latest update from Adobe:

www.adobe.com/products/photoshop/
cameraraw.html

Image size and print size

Resolution describes how many pixels your image file contains, but most importantly, it tells you how large a print you can make.

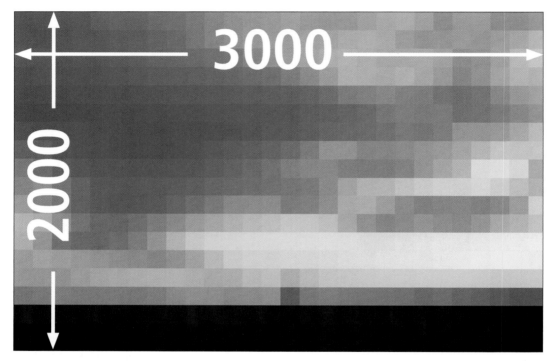

Think in pixel dimensions, not inches
Digital image files are best visualized in pixel dimensions, rather than inches or centimeters, as shown above. To make a photo-quality inkjet print, you need to have 200 pixels per linear inch (ppi), so a file measuring 3000×2000 will print out at 15"×10". The more pixels your image contains, the bigger and better print you can make. These dimensions are always determined by your camera settings, as shown right.

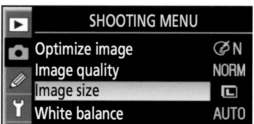

Set the size in your Shooting menu
Most cameras have three image size options in the shooting menu: large, medium or small.

Image, document size, and print size

Before beginning any project, it's useful to understand the link between your chosen camera settings, the file once opened in Photoshop Elements, and the eventual printout size. The diagram above shows three different image size camera setting menus along the top row. In the middle row is the Image Size dialog box, showing the pixel dimensions of the unedited file. In the Document Size panel of the dialog, the final print size (bottom row) is indicated. High-resolution images are those constructed from many millions of pixels and are capable of making pin-sharp photographic prints at 200 pixels per inch.

Megapixels or pixel dimensions?

Confusingly, many camera manufacturers choose to describe image size in megapixels rather than the more accurate pixel dimensions. Put simply, the megapixel number describes the total number of individual pixels when the dimensions are multiplied together. In the above example, the Large Size is also described as 10 MP (megapixel), because 3872×2592 = 10,036,224.

The megapixel count is really only useful when working out the maximum shooting quality of an individual camera, as you can't work out length and width dimensions from a single-pixel count number such as 10 MP.

Color management

To ensure your colors stay accurate between editing and printout, it's essential to set up your system properly from the start.

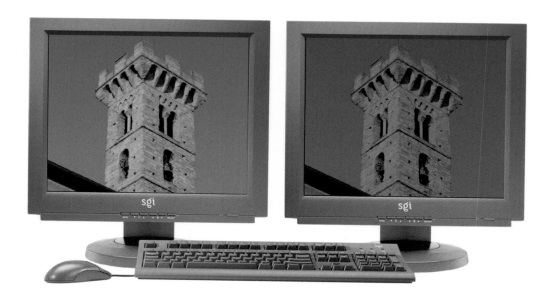

Setting up a consistent color palette

In digital photography, there is no universal standard color palette; instead, there are two commonly used palettes: Adobe RGB (1998) and sRGB. The former is the largest and best one to use. Before printing your images, it's essential to shoot and edit in the same color palette. Problems occur if you shoot in the large palette and then edit in the smaller one, since the color of your pixels will be converted incorrectly, shown above right. If your camera can shoot in the Adobe RGB (1998) color space, then choose this option in your Shooting menu and set up Photoshop Elements to work with that space too.

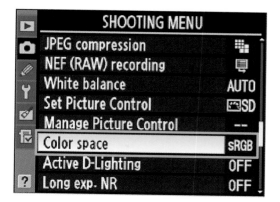

Adobe RGB (1998) or sRGB palette?

If your camera doesn't have any color space options in its Shooting menu, then by default it will be set to shoot in the sRGB space.

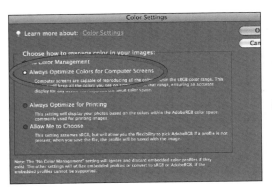

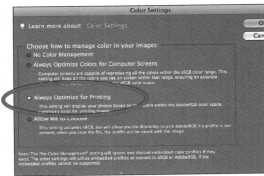

sRGB user settings

If your camera can only shoot in the sRGB color space, you need to select Edit > Color Settings and choose the Always Optimize Colors for Computer Screens option, as shown above.

Adobe RGB (1998) user settings

If you can shoot in the Adobe 1998 (RGB) space, change the Color Settings to Always Optimize for Printing.

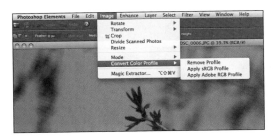

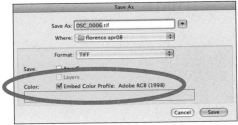

Converting color profiles

If you are editing older image files or files from an unfamiliar source, then they could be tagged with a nonstandard color space, or none at all! To ensure that you are always working in a consistent manner, choose the Image > Convert Color Profile command, as shown above, and choose the Apply option that corresponds with your chosen color workspace.

You'll likely avoid disappointing results at the printout stage if the color settings are the same throughout.

Embed the color profile when saving

With an eye on future editing projects, or when preparing files for a printing service, you should always double-check that the color profile is embedded when saving. This option is found on the bottom of Elements' Save As dialog box, as shown above, and ensures that the file carries a reference to its color palette. This invisible tag is used by photo applications and online printing services to ensure that your original colors remain accurate and reproduce vividly.

4

Printing

Print interface essentials

If you can drive the printer software with confidence, you'll make fewer mistakes and always get top-quality output.

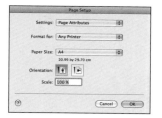

Choose a printer in Page Setup

The first step you need to make before printing is to select File > Page Setup, until the dialog box shown at left appears. In the Format for drop-down menu, choose the printer that you want to target.

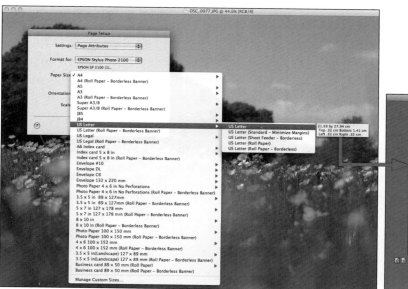

Understanding the importance of Paper Size

Once you have selected a printer in the Page Setup dialog, an Epson Stylus Photo 2100 in the example above, the options in the Paper Size drop-down menu change. Now, all the printer's standard sizes display, along with further options for using roll paper feed or printing with a CD tray attachment.

The Print window

The paper size chosen in Page Setup will be displayed as the white background page in the Print menu, as shown above. Every image you choose to print will now be displayed in proportion to this paper size.

The Print preview

After you select a File > Print command, your image will be displayed in a tiny preview window, so you can see if it's in the right orientation and proportion, as shown left. In this example, the image exceeds the paper size on both the right and left edges.

Rotating the image

To solve the above problem, click on either of the tiny flip icons, as shown left. This command will rotate your image to fit into the shape and orientation of your chosen paper size.

Rotating the print paper

If the orientation is incorrect—for example, if you are trying to make a letter-sized image print sideways—click either of the icons, as shown left, to rotate the print paper. This will override any previous orientation settings that you've chosen in the Page Setup dialog.

PPI and photo-quality printing

It's important to use the correct pixels-per-inch setting when preparing image files to print, or your results will look disappointing.

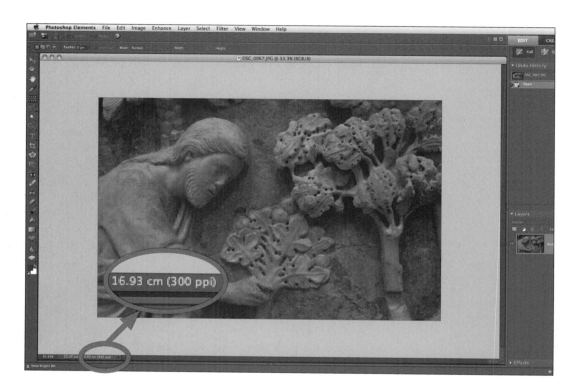

Check the pixels-per-inch setting

All images are saved and stored with a default pixels-per-inch setting (ppi), such as 72 ppi or 300 ppi. However, when making inkjet prints, it's essential to prepare your images at 200 ppi, so you can get the maximum size photo-quality print from your file. In Photoshop Elements, the ppi setting is displayed at the bottom left of the image window, as shown above. The ideal value is 200 ppi.

How big is a pixel?

Unlike real-world artifacts, pixels actually don't have a fixed size. Instead, you determine their size by setting the ppi in your image-editing application. The original data created by your camera only determines the pixel color, not its size. Pixels are scalable in size and you can make your pixels 1 yard square or make 200 fit into a linear inch!

Printing at 72 ppi (too low)

If you've tried to print an image you've downloaded from a web page, you know it will look like the example at left. Images prepared for viewing through a web browser are created at 72 ppi, but at this setting the pixels are clearly visible as blocky square shapes and too big when printed out.

Printing at 200 ppi (just right)

To make your image file into a photo-quality print it's essential to make the pixels small enough to become invisible to the human eye. When prepared at 200 pixels per inch, images will print with perfect detail and with no sign of square pixels. You'll also achieve the biggest print size possible from your file.

Printing at 300 ppi (too high)

If your image is set at 300 ppi, you'll still make a pin sharp photo-quality print, but because you have made the pixels too small, the overall size of your image will be smaller too. The print shown left was made from the same image file as the 200 ppi example but reproduces smaller on the paper because it's been printed at 300 ppi.

Changing to 200 ppi

If you need to alter the ppi setting, select Image > Resize > Image Size, as shown right. Make sure the Resample Image option is unchecked, then enter 200 in the Resolution box and click OK.

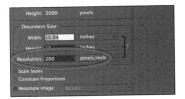

Solving paper size problems

Working across three different printer software dialogs can sometimes be confusing, so keep your process simple from the start.

Starting point

Sometimes, when you prepare an image for printing, it appears cropped or tiny in the Print preview window. The example shown left is an image measuring 3000×2000 pixels and is big enough to make a 15"×10" print.

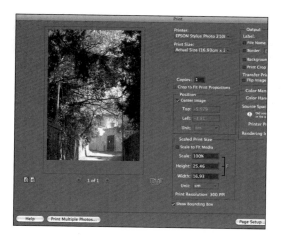

Paper size is too small

In the example shown above, only the center part of the image appears in the Print preview. This was caused by a too small paper size, in this case 6"×4". To solve this problem, go back to Page Setup and pick Letter or bigger.

Paper size is too big

The opposite problem occurs when your image looks as small as a postage stamp in the Print preview. The example shown above was caused by a 34"×17" paper size, which is too large for this image file. Solve the problem by returning to the Page Setup dialog and choosing a smaller size.

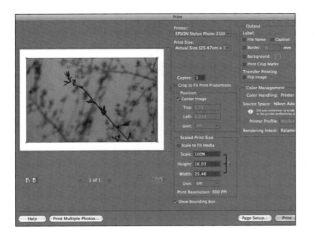

Printing with a border

Many inkjet printers can't make edge-to-edge prints without borders, so it's wise to leave a little white space around the outside. For those inkjets that can make borderless prints, you must choose a special paper size setting in the Print Setup dialog first.

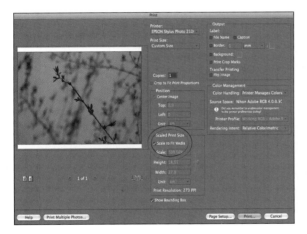

Uneven borders

If your image appears in the Print preview window with uneven borders, as shown left, it's been scaled up automatically using the Scale to Fit Media button. This command squeezes the image until it fits your chosen paper size, but it doesn't look especially great.

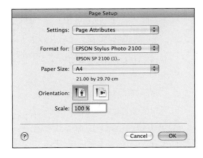

Page Setup settings

If you choose to use the Orientation and Scale commands in the Page Setup dialog rather than the Print dialog, it can get confusing! The best option is to leave the Page Setup controls at their defaults, Portrait for Orientation and 100% for Scale, then make all adjustments in Elements' Print dialog.

Scaling up and down

Images are rarely exactly the right size for printing, but you can scale them easily in the Print dialog.

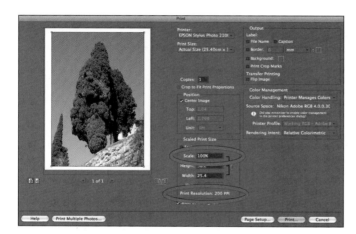

Default position

In the example shown left, the image is displayed at the default 100% scale, on the current paper size and at the ideal Print Resolution value of 200 ppi. This means there's been no scaling up or down. If you want to make the image appear bigger or smaller on the paper, you need to make adjustments.

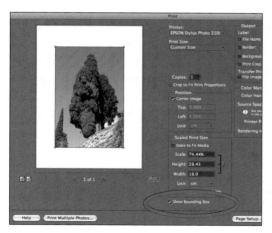

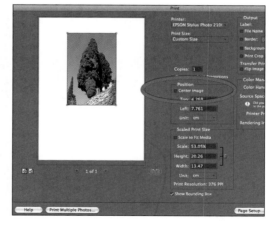

Scaling with the bounding box

Click Show Bounding Box, as shown above, to reveal four handles at the corners of your image. Slide any handle to the center to make the image smaller, or to the edge to make it bigger. Notice how the Resolution value has increased to 268 ppi, because we've scaled it down.

Drag-and-drop positioning

If you deselect the Center Image position, you are free to drag and drop your image anywhere on the page. Simply place your cursor over the image and drag into the new position. The example shown above has been placed slightly higher than center.

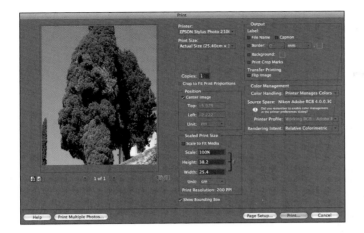

Image too big for paper

When printing from very high resolution files, you'll encounter the situation shown left. The image extends beyond the edge of the paper and even though the Bounding Box option is checked, you can't see the handles to move them. The only way to scale the image down is to use the Scaled Print Size controls.

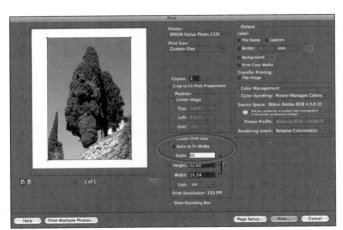

Using Scaled Print Size

In the Scale box, as shown left, enter 60. This increases the ppi above the ideal 200 to 333. This won't make the image any sharper to the eye but won't make it any worse either. When you scale in the Print dialog rather than Elements' Image Size dialog, the alteration to the ppi is only temporary. The image now sits in the center and can be scaled with the Bounding Box option if you wish.

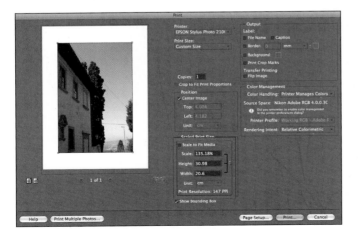

Image too small for paper

The example at left shows a low-resolution image scaled up to fit the paper size. The only problem now is that the print resolution has now dropped below the ideal 200 ppi to 147 ppi, which will result in a blurred or pixelated printout. When a low-resolution image is scaled up, in this case enlarged to 135%, the pixels become visible on the printout.

Making test prints

There's no sense sending a full-sized image to print if you can send a smaller test print instead. You'll save on ink and paper, too.

Printing a selection

Edit your file until it looks ready to print, then choose the rectangular marquee tool, as shown above. Make sure the Feather value is set to 0, then draw a rectangle around an area in your image where both highlights and shadows occur. Next, select File > Print and then choose the Custom Size option from the Print Size dialog, as shown right. The print window will now display the selection you've made, which can be sent to print as usual. You can even choose to print the test more economically on a smaller piece of paper.

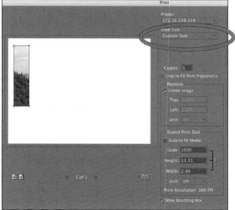

Judging the results

You'll make at least two test prints using this technique, but use far less ink than you would printing a full sheet. The ideal print shows all details in both highlight and shadow areas simultaneously. You can judge this by looking into the darker areas of your test and checking that no areas of full black exist where the ink has filled in the details. Above are two tests made from the same image file, with the lighter, right-hand example looking the best. Although some colors look richer when they are darker, don't sacrifice details to achieve that look!

How printer software works

The final and most important barrier to cross is the printer software, which controls how ink is placed onto your paper.

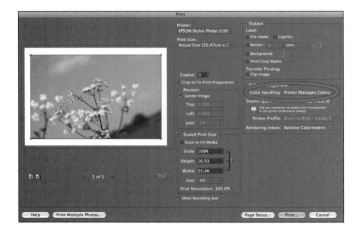

Choose Color Handling

There are two methods of converting colored pixels into ink droplets to spray on paper: using the standard printer driver software or using specially made paper profiles (see pages 74–75). To use the printer software, you must ensure that the Color Handling option is set to Printer Manages Colors, as shown left.

What the driver does

Printer driver dialogs all contain the same kinds of settings and are designed to help you get the very best out of your ink and paper media. The most important drop-down menu, shown left, contains submenus for controlling print quality and color accuracy.

Most mistakes are made here!

The decisions that you make in the printer software have more of an impact on the quality of your final print than the editing steps you've made in Photoshop Elements.

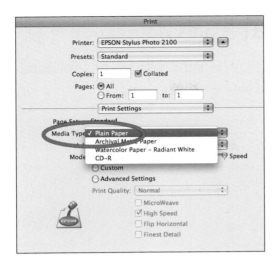

Tell the driver the directions

The Media Type drop-down menu contains the most important controls in the dialog. Here are displayed several "recipe" settings that determine the quantity and size of ink droplets to place on your paper. For an absorbent uncoated paper such as Plain Paper, the setting tells the print head to spray big ink drops far apart on the paper so they don't merge together. For a quality paper, such as Archival Matte, the setting makes the print head spray the finest dots very close to each other, because the dots won't spread on the paper. It's essential to match your paper surface type to one of these settings.

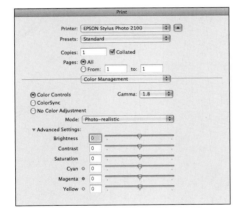

Color management controls

In the Color Management drop-down menu are several controls for adjusting the appearance of the print. The Advanced Settings panel includes six sliders for controlling color and contrast (more on these on pages 72–73). Each time you change a setting, the resulting print will turn out differently, so it's important at this stage to move as few controls as possible, or it will be impossible to know which one has caused the problem!

Get the latest printer driver

No matter how old your inkjet printer is, it's well worth checking if its printer driver has been updated. A driver is the piece of software that controls the physical heads in a printer, and most printer manufacturers update their drivers to improve print quality, to work better with new operating systems (like Windows Vista), and to provide settings for printing with new types of paper. The drivers are always free and quick to download from the Internet.

Saving printer settings

If you spend time experimenting with your printer settings, you can save your hard work as a preset, ready to use next time.

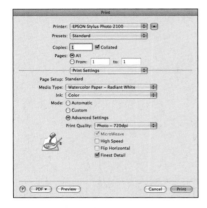

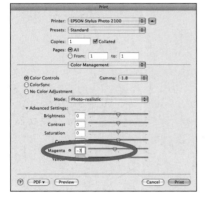

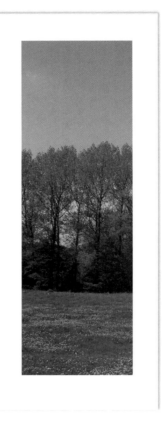

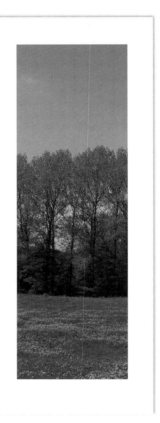

Arriving at a good balance

If you are striving for the best kind of print from your paper and ink combination, then it pays to try a few different settings to see which work best. In addition to the Media Type setting, the Print Quality options will have a profound effect on the overall color and density of your print. It's worth testing your paper using 720, 1440, or 2880 dpi to see which looks best.

In this example, the first test print, shown above middle, was slightly magenta. A second test print was made, but this time the magenta was reduced using the Color Control sliders, shown above left. The final print, above right, shows much less magenta, which in turn makes the green grass more vivid on the print.

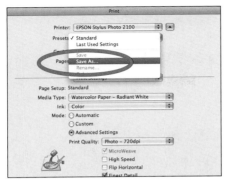

Saving your settings recipe

Once you have arrived at a satisfactory conclusion to your testing, you can save and store the settings for next time. In the Presets pop-up menu, choose the Save As option.

Giving the preset a name

To make it easy to retrieve your special recipe, name the preset after the paper you are using.

Using the preset to make your next print

Next time you decide to output on the same paper, simply choose your saved setting from the Presets menu.

Download free printer test images

The best images to use to test your paper, ink, and printer settings are properly made test files. These contain the full range of color and neutral tones, making evaluation much easier. This free example by Bill Atkinson can be downloaded here:

www.billatkinson.com

Understanding paper profiles

If you don't want to jump through hoops every time you make a print, try using purpose-made profiles.

When to use profiles

If you are happy enough to use an Epson printer with Epson inks and Epson paper (and the same follows for Canon and HP users), then you'll get perfect print results just using the normal printer software.

However, if you want to try some of the more adventurous paper surfaces or finishes such as the stylish baryta paper from Harman, shown left, then you will need to print with a profile. Profiles are tiny files that are designed to "slot into" to your printer software, because it won't know how best to convert colors for the new style paper. A profile creates the ideal settings for the three combined elements in your workflow: printer model, ink type, and paper type. Change one of these and the profile becomes useless.

Where to put them

All third-party paper manufacturers provide profiles, shown left, free of charge through their website, based on your printer, ink, and paper combination. After downloading, Windows users simply right-click and choose Install to send the files into the right system software folder. Mac users need to place the files in Macintosh HD / Library / ColorSync / Profiles. Once installed, they become available to choose in your image-editing application.

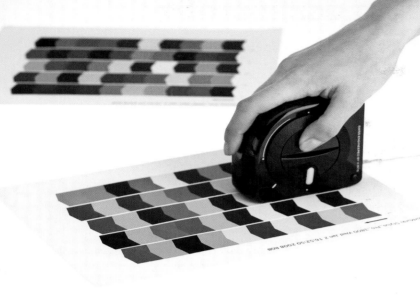

How profiles are made

To ensure end users get the very best results out of their paper products, manufacturers provide carefully created profiles for free. A paper profile is made by scanning a color test chart with a special profiling hardware instrument like the ColorMunki, as shown above. The test chart file (see example at right) is made with specially chosen colors, then printed out on the inkjet in question. The profiling device then scans the colors that have printed and calculates how to make them brighter. The profile file essentially works by translating the colors of your image into ink droplets, so the end result is saturated and most of all accurate. If you haven't tried using profiles before, they are well worth the effort and you will see a huge jump in productivity and quality.

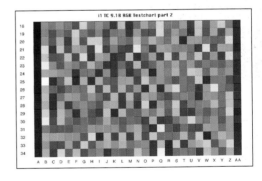

Make your own profiles

Nowadays, the cost of a profiling kit is about the same as a good-quality inkjet, so it's easy to make your own profiles. If you like experimenting with nonstandard inkjet media such as artists papers, then a custom profile will really improve the quality of your prints, and best of all, it will be designed especially for your workflow.

Making a print with profiles

It's essential to follow the correct sequence when printing with profiles, or you won't get the best out of your chosen paper.

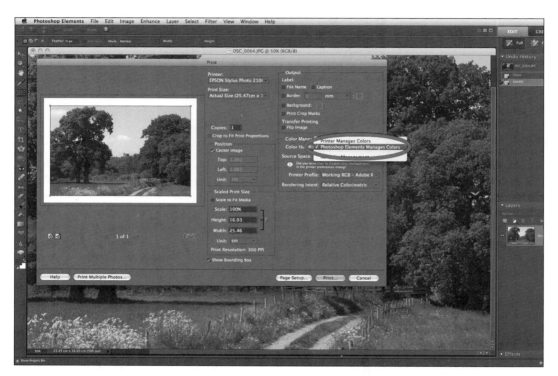

1 Choose the color handling

In the Color Management panel, pick Photoshop Elements Manages Colors from the pop-up menu, as shown above.

2 Pick the printer profile

Next, click the Printer Profile pop-up menu and pick the profile for your chosen paper, print, and ink combination. The example shown right is a profile for Harman Matt fiber-based paper using Photo Black ink on an Epson 2100 printer.

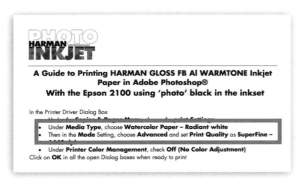

3 Check the instructions

Next, check the sheet of instructions that were provided with your paper or as part of the profile download package. The instructions will tell you the media type to choose and the print quality settings in your printer software dialog.

4 See the soft-proof

Next, click on the Rendering Intent box and set it to Perceptual or to the setting recommended on your paper profile instruction sheet. Notice how the preview image now predicts its appearance on your chosen paper in a state called the soft-proof.

5 Set Media and quality

In the Photoshop Elements print screen, click Print. For the Harman paper, shown left, the Media Type was set on Watercolor Paper – Brilliant White, and the Print Quality was set to 1440 dpi.

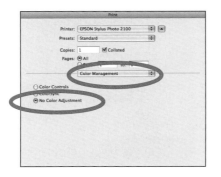

6 Turn off Color Management

The final step is to switch off the color controls. Go to the Color Management menu, as shown left, and choose the No Color Adjustment option. This now clears the way for the profile to make the color conversions from file to ink. If you left the Color Controls option enabled, you'd have two different tools completing the task!

Sharpening your images

Just before you send an image to print, you can reveal even finer details by using the Unsharp Mask filter.

How sharpening works

All digital cameras are designed with an internal softening filter to prevent antialiasing. This essentially occurs because square pixels don't do a good job of describing curved shapes in a scene, making them jaggy or staircased instead. To prevent this, the antialiasing filter inside your camera deliberately softens the image by lowering the contrast all over. It's not your focusing that causes soft images; it's just the way the camera is designed.

All digital image files therefore benefit from some sharpening before printing, and you will be surprised at the number of hidden details that can appear afterward. The best tool to use is the Unsharp Mask (USM) filter, as its effects can be controlled precisely. The USM works by increasing the contrast at the edges of shapes in your image, but it can be overdone if pushed too far. Always apply the filter as the very last command before printing, because if you edit afterward, its effects will be magnified.

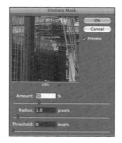

The USM dialog

For simple sharpening, start with the Amount value, shown left, on 50 and leave both Radius and Threshold at 1. On the facing page are five examples of the filter in use, each using different Amount settings. Which one do you think looks best?

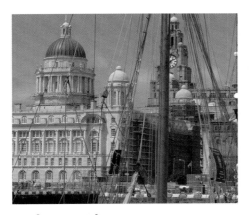

Unsharpened

Amount 50, Radius 1, Threshold 1

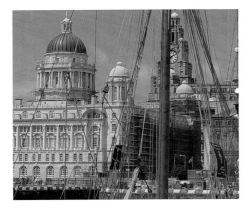

Amount 75, Radius 1, Threshold 1

Amount 100, Radius 1, Threshold 1

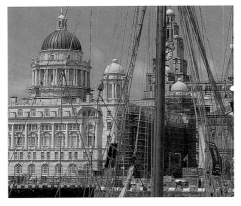

Amount 150, Radius 1, Threshold 1

Amount 200, Radius 1, Threshold 1

5

Color styles

Color essentials

If you understand the way color works, you'll be able to make creative decisions and solve a variety of problems, too.

Six players and three couples

When starting to think about color in printing and photography, forget about how you mixed paint in school! Instead, a six-color palette with three primaries is used: red, green, and blue. Opposite each of these are their secondary colors: cyan, magenta, and yellow. All color controls in image-editing software work with these pairs: red + cyan, green + magenta, and yellow + blue. There are no other colors you need to think about! This relationship is expressed through the color wheel, as shown left.

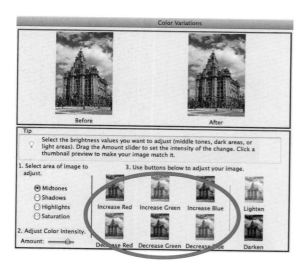

Color casts and the color wheel

All images contain some kind of rogue color, usually caused by poor lighting or environmental influences. If you shoot a portrait in daylight with your subject in the shade of a big green tree, everything in the image will look green. This is because the leaves have made the light appear green. Yet removing green from your image is simple: increase the amount of its opposite color, magenta, and as if by magic, it will disappear! Elements' Color Variations controls, shown left, provide the three pairs as six color buttons so you can easily remove unwanted color casts.

What is hue?

Hue is really just another word for an individual color like red, yellow, or green. The example above shows many different hues in the same frame. In Photoshop, you could change the hue of the yellow flowers to red.

What is saturation?

Saturation describes the intensity of a color or hue. When a color can't get any more vivid, it's said to be fully saturated. The red flowers above are fully saturated, but the purple ones could be saturated further in Photoshop.

Warming up

Many a good shot is dominated by cold blue natural light, yet you can remove this quickly by using a photo filter.

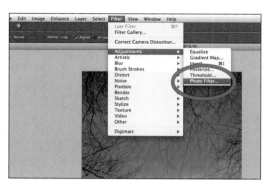

1 Solve cool lighting conditions

If you shoot outdoors in early morning, mid-winter, or when there's no direct sunlight, all of your images will be covered with a thin veil of blue. This color cast prevents other subtle colors from shining through.

2 Apply a Warming filter

The simplest way to correct this problem is to use a photo filter. From the Filter menu, select Adjustments > Photo Filter, as shown above, to open the Photo Filter dialog box.

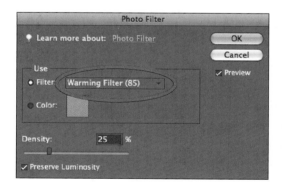

3 Warm up with a number 85

The orange Warming filter number 85 is the best choice for removing an overall blue cast. Experiment also with the Density value, but keep it below 30%.

Media and printer settings

Brand:	Harman
Product:	**Gloss FB Warmtone**
Texture:	Air-dried gloss
Weight:	320 gsm
Base:	Cream baryta
ICC profile:	harman-inkjet.com
Inkset:	Photo black
Media type:	**Premium Glossy**
Resolution:	1440 dpi
Expert tips:	Warm results with this cream paper

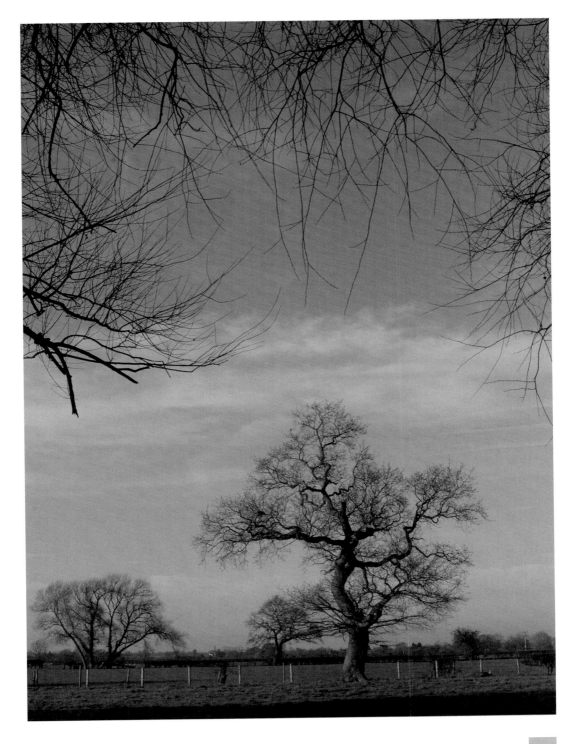

Muted color

To create a pastel effect print, try decreasing the color saturation and printing on a rich art paper.

1 Use a flower study
A good subject for this technique is a simple graphic flower study. The example shown above contains just three dominant colors and one repeating flower shape.

2 Adjust the Hue/Saturation dialog
There are plenty of tools and techniques for changing and improving color, but only one for draining it away in precise amounts. From the Enhance menu, select Adjust Color > Adjust Hue/Saturation.

3 Edit the Master channel
You can edit colors in the Hue/Saturation dialog, or modify them all at once under the Master channel. To reduce the overall color intensity, decrease the Saturation, as shown above.

Media and printer settings

Brand:	Innova
Product:	**Soft White Cotton**
Texture:	Matte watercolor
Weight:	280 gsm
Base:	100% archival cotton
ICC profile:	www.innovaart.com
Inkset:	Photo black
Media type:	**Smooth Fine Art**
Resolution:	1440 dpi
Expert tips:	Aim for pastel tones, not intense colors

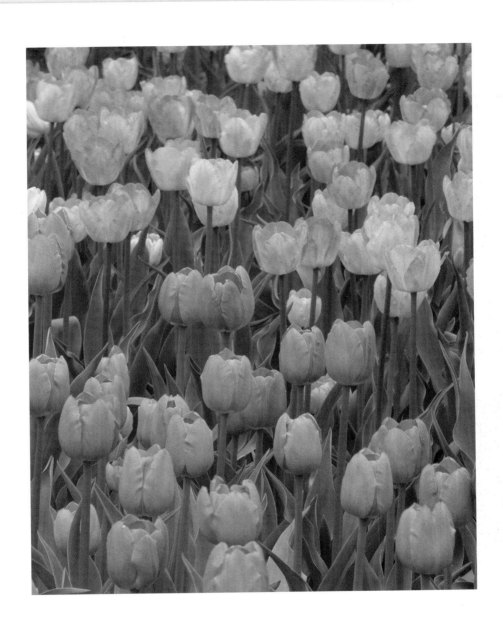

Color and mono combined

This technique is a simple way of merging the best parts of two different versions of the same image.

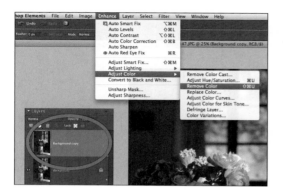

1 Prepare the layers

To start with, choose Layer > Duplicate Layer, so your Layers palette looks like the example above. Click on the Background Copy layer to make it active, then select Enhance > Adjust Color > Remove Color.

2 Color removed

Your image should look like the one above, with a mono image layer floating above your colored starting point. Next, pick Hue from the Layers blending mode pop-up menu to define how color "reacts" in the next step.

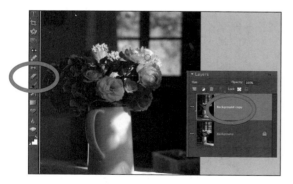

3 Erase the color back in!

Set the Eraser tool, as circled above, with a soft-edged 45-pixel brush. Working on the Background Copy layer, slowly apply the brush over the areas you want to recolor. If you make a mistake, use your Undo History to reverse your changes.

Media and printer settings

Brand:	Moab
Product:	**Entrada Rag Natural**
Texture:	Smooth watercolor
Weight:	300 gsm
Base:	Cream; rag paper
ICC profile:	www.moabpaper.com
Inkset:	Matte black
Media type:	**Smooth Fine Art**
Resolution:	1440 dpi
Expert tips:	**Enhances muted color images**

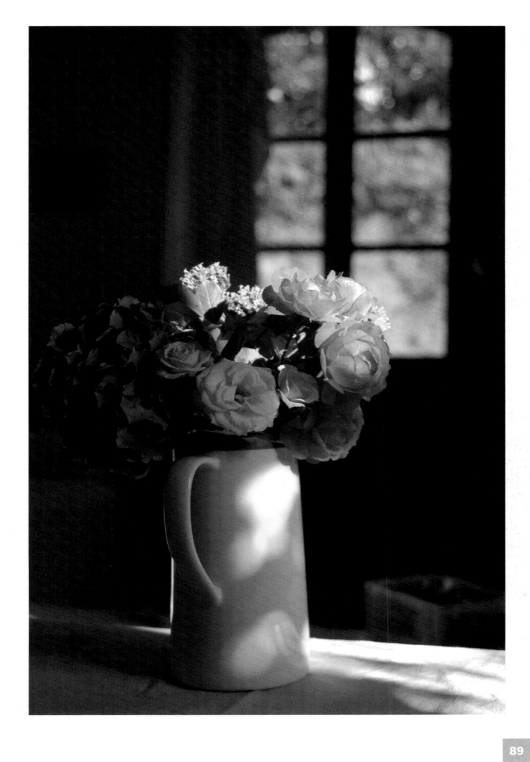

Watercolor style

Enhance your landscape imagery with a subtle watercolor filter from Photoshop Elements' filter pack.

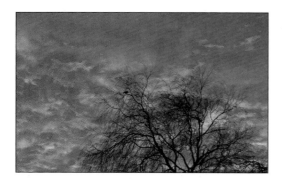

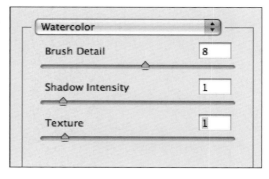

1 Choose the right image to start

Watercolor filter effects look best when applied to landscape images that have plenty of tonal interest. The example above was chosen because of the contrast between the black tree and the delicately colored sky.

2 Experiment with the settings

Select Filter > Artistic > Watercolor to reveal the three slider tools shown above. The Brush Detail slider creates fine results at the 8–10 end and coarse brush marks at 1–3. Keep the Shadow Intensity and Texture both at 1.

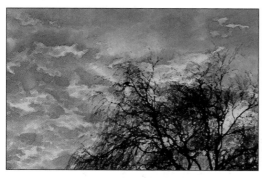

3 Push and pull the detail

The trick with this filter is to keep playing with the Brush Detail slider to maintain fine details, but not render the effect unnoticeable. The final Brush Detail setting for this example was 8.

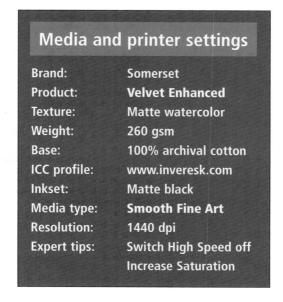

Media and printer settings

Brand:	Somerset
Product:	**Velvet Enhanced**
Texture:	**Matte watercolor**
Weight:	**260 gsm**
Base:	**100% archival cotton**
ICC profile:	**www.inveresk.com**
Inkset:	**Matte black**
Media type:	**Smooth Fine Art**
Resolution:	**1440 dpi**
Expert tips:	**Switch High Speed off**
	Increase Saturation

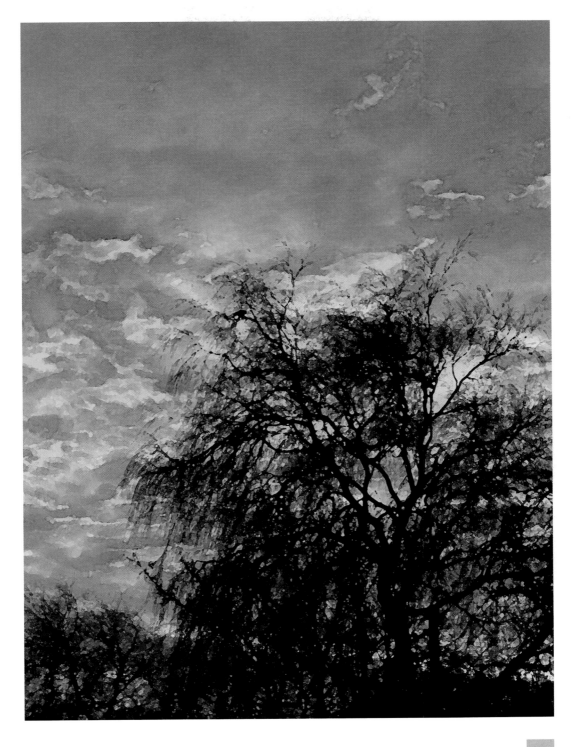

Vivid color

Photoshop Elements' Curves controls are the best way to liven up weak or washed-out colors.

1 No strong colors

Although the original subject was brightly colored, the lighting on location was flat. The initial file, shown above, looked gray and lacked visual emphasis, as is typical of shots in JPEG format.

2 Adjust Color Curves

From the Enhance menu, choose Adjust Color > Adjust Color Curves. The Curves controls are an effective one-stop shop for boosting contrast, brightness, and color saturation.

3 Start with a style

Click on the Increase Contrast Style option, as shown above, and watch how the image is boosted. This preset creates a gentle sloping S-shaped curve, but you can customize it further by using the slider controls.

Media and printer settings

Brand:	Moab
Product:	**Colorado Gloss**
Texture:	Gloss Fiber base
Weight:	245 gsm
Base:	Acid/lignin-free paper
ICC profile:	www.moabpaper.com
Inkset:	Photo black
Media type:	**Premium glossy**
Resolution:	1440 dpi
Expert tips:	Single-sided media, handle by edges only

Tungsten in daylight

This look, adapted from a traditional film technique, creates a luscious palette of purple and blue shades.

1 Open your file in Camera Raw

Open the file in the Camera Raw plug-in (see page 53). It doesn't have to be a RAW format file; JPEGs or TIFFs will work too. The White Balance settings create the color effect shown above.

2 Design a Custom White Balance

The unique color effect is created by sliding the Temperature scale to −75, as shown above. This creates the purply/blue color without any complex editing.

3 Fine-tuning

Use the Exposure slider directly underneath the White Balance panel to lighten the image. Click Done when complete and then open the file in Elements to print.

Media and printer settings

Brand:	**Harman Inkjet**
Product:	**Matte FB MP**
Texture:	**Matte fiber base**
Weight:	**310 gsm**
Base:	**Baryta**
ICC profile:	**harman-inkjet.com**
Inkset:	**Matte black**
Media type:	**Glossy or watercolor**
Resolution:	**1440 dpi**
Expert tips:	**Will reproduce rich tonal range**

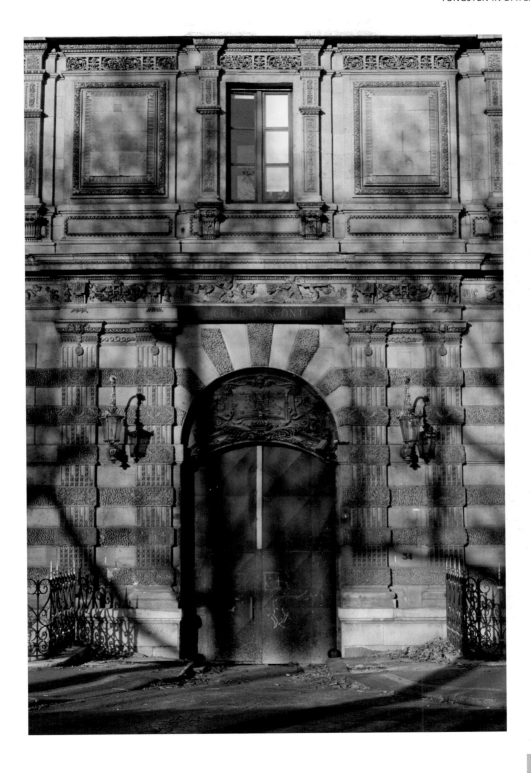

Graduated filter

For images with blank or pale skies, a graduated filter effect can help to add interest.

1 Starting point

Select the Gradient tool and then click in the Gradient Picker at the top left of the desktop. Next, choose the Foreground to Transparent option, as shown above.

2 Choose your foreground color

The color of the effect is determined by the foreground color you choose. Click on the Color Picker and choose a vivid orange.

3 Set the blending mode

The trick with this effect is to make the new orange color blend seamlessly with the color in your photograph. From the Mode drop-down menu, pick the Color option.

4 Set the opacity

To ensure that the filter can be applied in a convincing manner, you need to change the Opacity value from its default 100%. Click on the slider and set at 30%.

5 Dragging the gradient

Position your Gradient cursor at the top of the image and Shift-drag down, as shown above. To intensify the effect further, repeat the Shift-drag in the same place.

Media and printer settings

Brand:	Permajet
Product:	**Oyster 271**
Texture:	Pearl
Weight:	271 gsm
Base:	Resin-coated paper
ICC profile:	permajet.com
Inkset:	Photo black
Media type:	**Photo Glossy**
Resolution:	1440 dpi
Expert tips:	UV coated media, ideal for display

Before

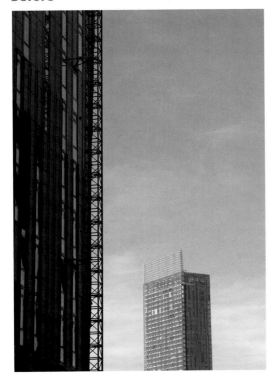

After

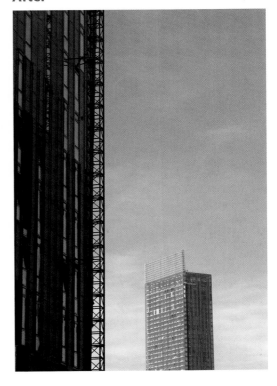

Polarizing filter

Boost the contrast in muted blue skies with an edit designed to resemble the look achieved with a screw-on lens filter.

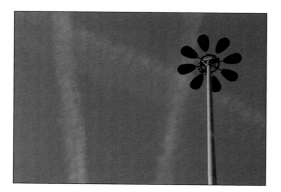

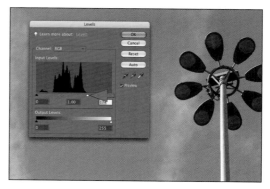

1 Starting point

Straight out of a digital camera, most images look lackluster. The plan for this example is to make the blues more vivid and increase the contrast with the white vapor trails.

2 Adjust the contrast with Levels

To improve the overall contrast, select Enhance > Adjust Lighting > Levels. Drag the Highlight slider to the left so it sits under the base of the histogram shape, as shown above.

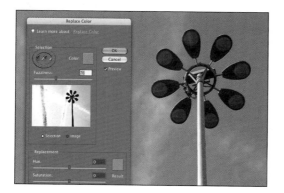

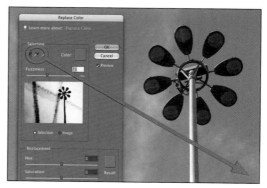

3 Use Replace Color

Next, select Enhance > Adjust Color > Replace Color. In the Selection panel, click on the dropper tool, as shown above, and then choose the Selection preview option.

4 Sample the color to change

Click the dropper into the bluest area. The color you choose will show up as white in the Selection preview window. To increase or decrease the density, use the Fuzziness slider.

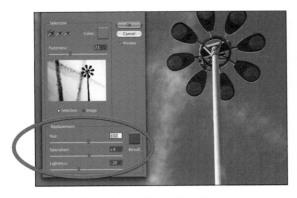

5 Modify the selected color

In the Replacement panel, darken the blues by decreasing the Lightness value. Next, increase Saturation and choose a more vivid blue by moving the Hue slider to the right.

Media and printer settings

Brand:	Harman
Product:	**Gloss FB Al**
Texture:	Air-dried gloss
Weight:	320 gsm
Base:	Baryta fiber base
ICC profile:	harman-inkjet.com
Inkset:	Photo black
Media type:	**Premium Glossy**
Resolution:	1440 dpi
Expert tip:	**Touch dry instantly, but best left for 24 hrs**

Finished print

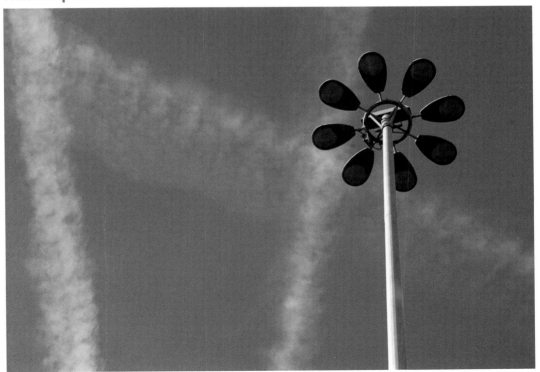

6

Mono styles

Conversion essentials

Turning a color image into dramatic black and white can yield an eye-catching end result.

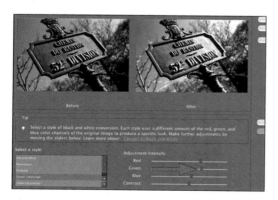

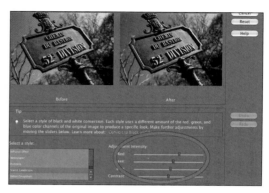

1 Poor conversions

The simplest way of turning an image into black and white is to decrease the Saturation in the Quick Color palette. However, the results can look a bit lifeless.

2 Convert to Black and White controls

Instead, select Enhance > Convert to Black and White. To heighten the dramatic impact of your image, you can darken or lighten the original colors by using the Adjustment Intensity sliders.

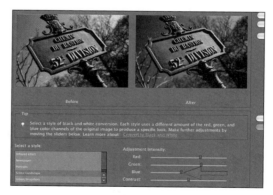

3 Lighten the greens

To create more contrast between the original balance of blue and green, increase the amount of green, as shown above. The green sign now looks lighter in comparison.

4 Darken the blues

Next, to darken the sky, decrease the amount of blue, as shown above. Don't move the red slider, as there's no red in the image. The result, shown right, is dramatic.

Before

After

High contrast

A high-contrast print can knock out unwanted details and color and make a more dynamic end result.

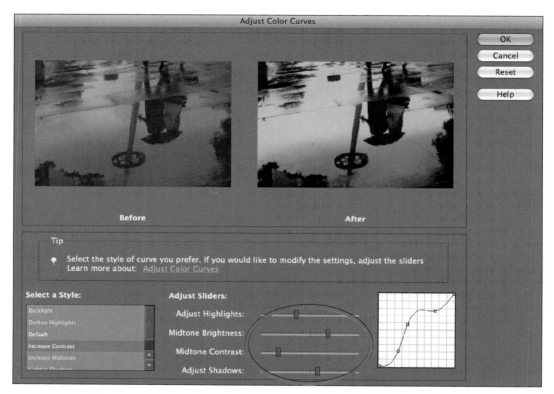

1 Convert the original

Believe it or not, the starting point to this project is a color image, shown above left. Shot on a rainy day, the original shot contains almost no color, so we're going to convert it to black and white to make it look more interesting. Start the edit by selecting Enhance > Convert to Black and White and choosing the Increase Contrast Style preset. An italic S-shaped curve appears; we will edit this further in the next step.

2 Manipulate the curve

Although the curve in Photoshop Elements can only be edited with four different methods—highlights, midtones, midtone contrast, and shadows—you can still create a high-contrast result. Move the sliders until the S shape of the curve starts to look like the example above. The more upright the italic 's' shape becomes, the more contrast you'll see in the image. If you go too far, click the Reset button in the dialog box.

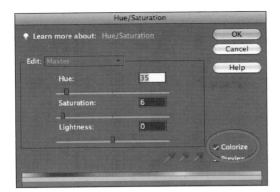

3 Add a simple tone

Click the Colorize check box in the Hue/Saturation dialog, as shown above, and reduce the Saturation value to 6. Move the Hue slider until you find a pleasing color.

Media and printer settings

Brand:	Innova
Product:	FibaPrint
Texture:	Warmtone Gloss
Weight:	300 gsm
Base:	Fiber-based
ICC profile:	www.innovaart.com
Inkset:	Photo black
Media type:	Smooth Fine Art
Resolution:	1440 dpi
Expert tips:	Will hold detail in very dark shadows

Finished print

Low contrast

By removing the deep blacks and bright whites from your image, you can make a delicate low-contrast print.

1 Choose the right subject

This is the perfect kind of image to convert into a low-contrast print. With just a slight contrast, the delicate shapes and texture of the flower head will really be enhanced by the technique.

2 Choose your preset style

In the Convert to Black and White dialog, choose the Scenic Landscape preset style, as shown above. This will create a tiny increase in contrast that will be pulled back in the next edit.

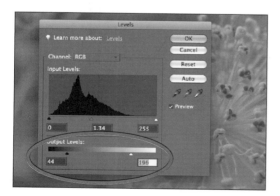

3 Reduce the contrast range

Open the Levels dialog and move the two Output Levels sliders to the center, as shown above. This defines the new bright and dark points, as can be seen in the finished print example far right.

Media and printer settings

Brand:	Hahnemühle
Product:	Bamboo
Texture:	Smooth cotton
Weight:	290 gsm
Base:	90% bamboo fiber
ICC profile:	Hahnemühle.com
Inkset:	Matte black
Media type:	Velvet Fine Art
Resolution:	1440 dpi
Expert tips:	Lighten with Levels if first print is too dark

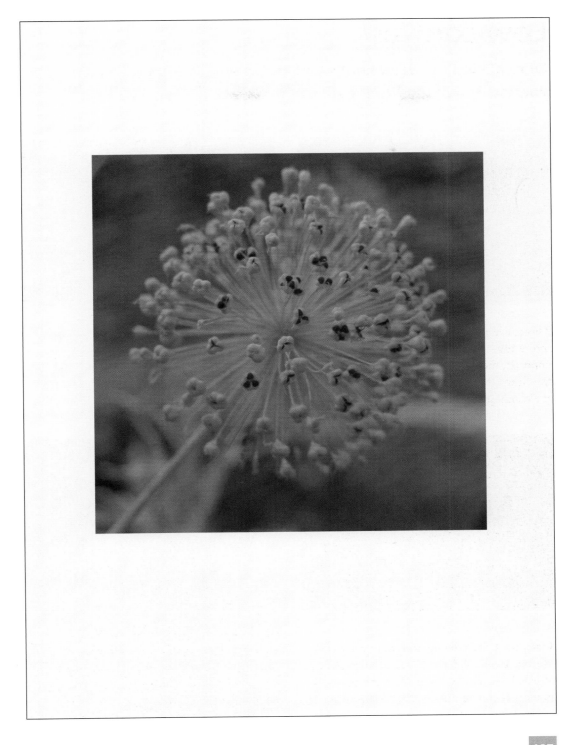

High key

Snow scenes always seem to turn out gray rather than pristine white, but you can bring back the sparkle of a high-key subject.

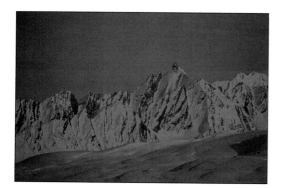

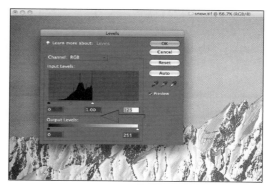

1 Underexposed starting point

This example, shown above, is a typical snow scene exposure, in which the camera meter has forced bright whites into a murky gray tone. Our task is to make them as bright as they were at the scene.

2 Remap the highlights

Open the Levels dialog and move the tiny white highlight triangle, as shown above, to the foot of the black graph shape. This will remap the highlights and remove the muddy gray from the image.

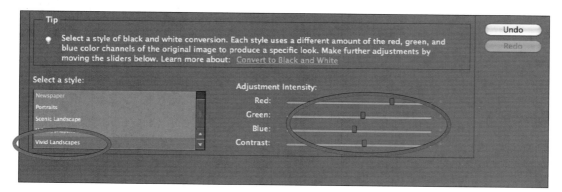

3 Convert with a style

Next, select Enhance > Convert to Black and White and click on the Vivid Landscapes style, as shown above left. This will apply a preset punchy contrast value to your image.

4 Fine-tune the conversion

If you had any strong colors in your original image, you can darken or lighten them by using the Adjustment Intensity sliders, as shown above.

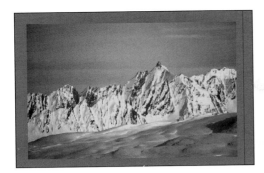

5 Lighten or darken?

The Adjustment Intensity sliders allow you to remap original colors to make them stand out more against each other. Negative values darken while positive values lighten. In the example above, blue was reduced to produce a darker sky compared to the original.

Media and printer settings

Brand:	Innova
Product:	**FibaPrint**
Texture:	White Gloss
Weight:	300 gsm
Base:	Alpha cellulose
ICC profile:	www.innovaart.com
Inkset:	Photo black
Media type:	Premium semigloss
Resolution:	1440 dpi
Expert tips:	Use Perceptual as the rendering intent

Finished print

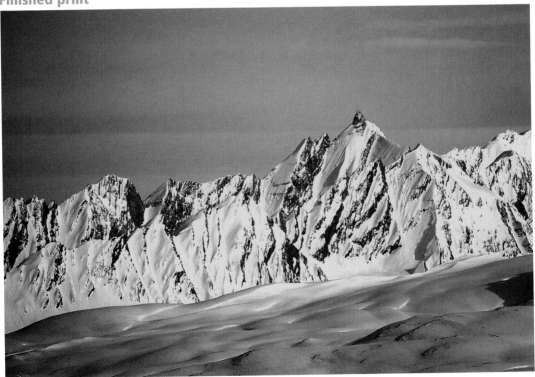

Low key

Camera light meters can't capture the subtleties of moody lighting in a single exposure, so you have to edit the atmosphere back in.

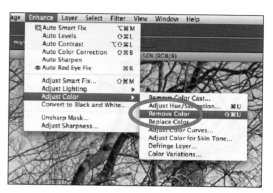

1 Understand your light meter

All camera light meters make exposures by finding a compromise between the light and dark areas in your chosen scene. Yet sometimes the results are brighter than you really want.

2 Bring back the atmosphere

Start by selecting the Enhance > Adjust Color > Remove Color command, as shown above. This will drain away the color and prepare the image to be darkened.

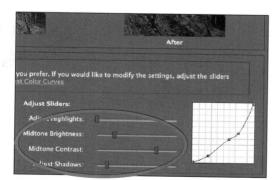

3 Darken with Color Curves

Open the Color Curves controls and set negative values for Highlights, Brightness, and Shadows, as shown above. Increase Midtone Contrast bit by bit, until it lightens without ruining the moody atmosphere.

Media and printer settings

Brand:	**Hahnemuehle**
Product:	**Museum Etching**
Texture:	**Matte watercolor**
Weight:	**350 gsm**
Base:	**100% archival cotton**
ICC profile:	**Hahnemuehle.com**
Inkset:	**Matte black**
Media type:	**Velvet Fine Art**
Resolution:	**1440 dpi**
Expert tips:	**Can also work with**
	Photo black inkset

Split contrast

For complex editing tasks, a combination of both high- and low-contrast effects can make a huge difference.

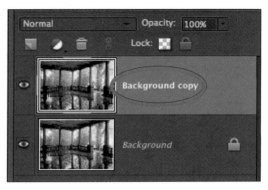

1 Starting point

This high-contrast original, shown above, proved to be a difficult image to edit, with complex shapes and borders making selection nearly impossible.

2 Duplicate the Background layer

The simplest way to mix high and low contrast is to create two versions of the image, then mix them together. Start with a Layer > Duplicate Layer command, as shown above.

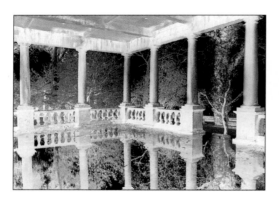

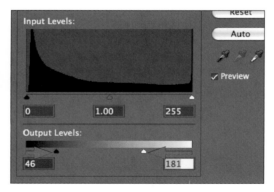

3 Invert the Duplicate layer

Next we need to turn the Duplicate layer into a negative by selecting Command/Ctrl+I. The image will reverse, with whites now black and blacks now white, as shown above.

4 Lower the contrast

Still on the Duplicate layer, open your Levels dialog and move both Output Levels sliders toward the center to lower the contrast, as shown above.

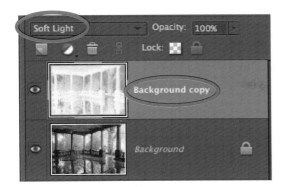

5 Merge the layers with a blend

To create a perfect mixture of the the negative and positive layers, click on the Duplicate layer, then choose Soft Light from the Layer Blend menu, as shown above.

Media and printer settings

Brand:	Moab
Product:	**Lasal Photo Matte**
Texture:	Smooth coated
Weight:	235 gsm
Base:	100% archival cotton
ICC profile:	www.moabpaper.com
Inkset:	Matte black
Media type:	**Enhanced Matte**
Resolution:	1440 dpi
Expert tips:	Good budget paper

Finished print

Gritty grain

To make your black-and-white prints stand out from the rest, why not mimic a traditional film processing technique?

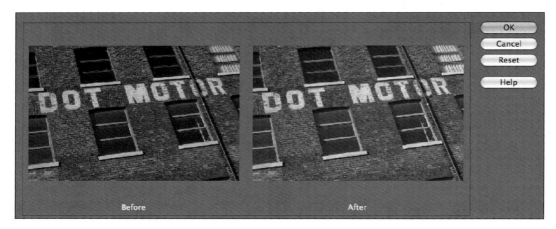

Before After

1 Convert to Black and White

Start off experimenting with the presets in the Convert to Black and White dialog, as shown above. Aim to create a conversion with some contrast, but without losing all signs of detail in the darker and lighter areas of your image. The example shown above was converted using the Newspaper preset.

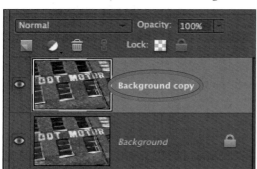

2 Duplicate the Background layer

Rather than risk applying a texture to the original Background layer, it's best to keep this edit separate. Select Layer > Duplicate Layer, until your Layers palette looks like the one above.

3 Apply the Film Grain filter

Working on the duplicate layer, select Filter > Artistic > Film Grain. In the Film Grain dialog, as shown above, aim for a mid-sized Grain value of 5, together with 10 Intensity.

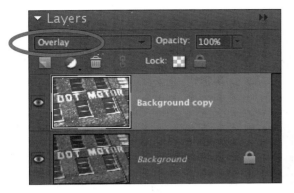

4 Blend the filter and the background

To achieve a more convincing end result, set the duplicate layer's Layer Blending mode to Overlay, as shown above. The texture and the original sharp layer are then merged to create greater contrast.

Media and printer settings

Brand:	Innova
Product:	**FibaPrint White**
Texture:	Semi-Matte
Weight:	300 gsm
Base:	Smooth fiber based
ICC profile:	www.innovaart.com
Inkset:	Matte black
Media type:	**Premium semigloss**
Resolution:	1440 dpi
Expert tips:	Thick media; check printer manual first

Finished print

7

Toning

Toning essentials

Toning is an ideal technique for making both grayscale and plain RGB color images more eye-catching.

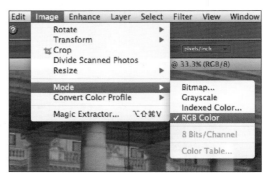

When to use toning

Before digital photography, only black and white images could be chemically toned, but today toning can be applied to color images too. The example shown above is an ideal subject for toning, since the amount of color is minimal.

Using the correct color mode

If your image is in Grayscale mode, you must convert it to RGB Color mode first, as shown above. If your image is already RGB, then desaturate by selecting Enhance > Adjust Color > Remove Color.

All-over color wash

You create simple toning by using the Colorize function in the Hue/Saturation dialog box. This function applies a single color wash over the highlights, midtones, and shadows, as shown above. See page 120 for more details.

Multiple tones

Complex effects can be achieved by using two different colors. The example above uses a yellow in the highlights and a red in the shadows, applied with Color Variations. See page 126 for more details.

Experiment with tone colors

Deeper hues, such as the three tones below, make for better toning compared to lighter, pastel colors. If toning colors are too light, they look washed-out when applied to midtone areas.

Deeper hues

Pastel color

Sepia toning

This classic tone is used for making landscapes images appear three dimensional and to evoke timelessness.

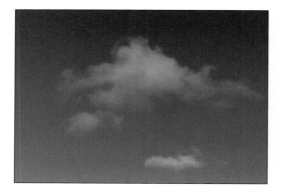

1 Starting point

Pick an image that would benefit from the toning process—one that has a rich tonal range, including whites and blacks, plus some textured elements too.

2 Colorize

Start by selecting Enhance > Adjust Color > Hue Saturation. In the bottom-right corner, as shown above, select Colorize. Drag the Hue slider to 40 and reduce Saturation to 25–30. This will create a rich sepia color.

3 Adjust the contrast

Toning often flattens the contrast a little, so to make it punchy again, open the Levels dialog. Move both highlight and shadow triangles toward the center, as shown above.

Media and printer settings

Brand:	Lumijet
Product:	Ultra Gloss II
Texture:	Glossy resin coated
Weight:	255 gsm
Base:	Microporous paper
ICC profile:	Hahnemühle.com
Inkset:	Photo black
Media type:	Glossy photo paper
Resolution:	1440 dpi
Expert tips:	Use Perceptual as the rendering intent

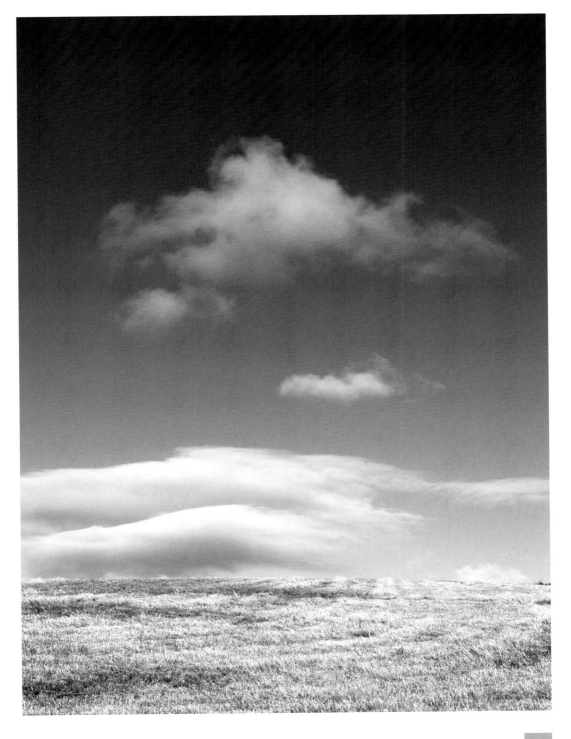

Hand tinting

Like transparent inks, Elements' Color Replacement tool allows you to tint your images.

1 Choose the tool

Start by clicking and holding the Brush tool icon to reveal the submenu, as shown above. Choose the Color Replacement Tool and set your brush to 100 pixels with 0% Hardness. This will ensure that your brushwork looks more true-to-life.

2 Paint with the Color Swatches

Rather than use the standard Color Picker to choose colors, open the Color Swatches palette through the Window menu. Begin by clicking on a midtone orange, as circled above. The Swatches palette stays on the desktop, making color changing fast.

3 Paint over your image

Paint with your brush and notice how the underlying image detail remains even after repeated applications with different colors. Keep changing color to make the tinting look realistic and eye-catching.

Media and printer settings

Brand:	Innova
Product:	**Cold Press Art**
Texture:	Matte watercolor
Weight:	315 gsm
Base:	acid-free wood pulp
ICC profile:	www.innovaart.com
Inkset:	Matte black
Media type:	**Matte heavyweight**
Resolution:	1440 dpi
Expert tips:	**Boost delicate colors before output**

Before

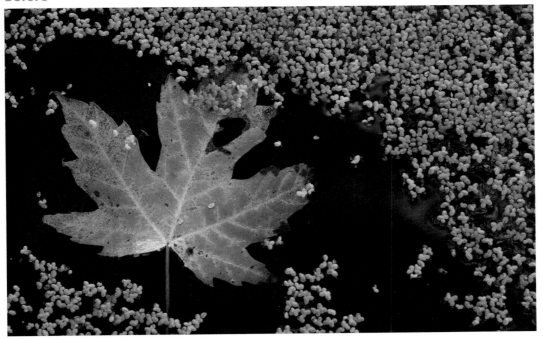

After

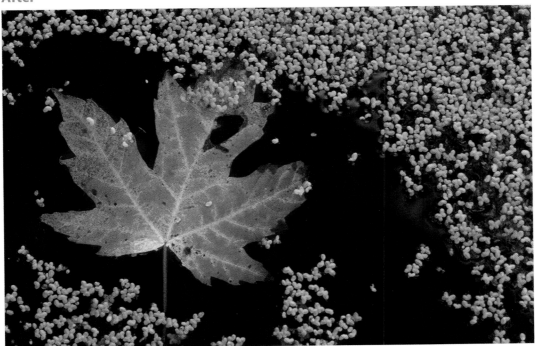

Blue toning

A delicate blue tone is the ideal color for enhancing monochrome winter landscapes.

1 Duplicate the Background layer

This effect is created by merging two identical layers. Start by selecting Layer > Duplicate Layer, so your Layers palette looks like the example above. Click on the copy layer so it receives the next edit.

2 Apply the filter

From the Filter menu, choose Adjustments > Photo Filter. From the Filter drop-down menu, choose the Cooling Filter (82) and set it with a 51% Density, as shown above. The image will now be deep blue in color.

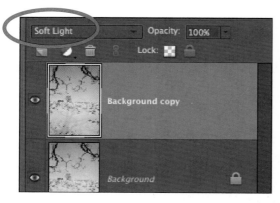

3 Blend the layers together

With the copy layer still active, choose the Soft Light blending mode, as shown above, to reduce the intensity of the color and enhance the overall effect.

Media and printer settings

Brand:	**Inkpress**
Product:	**Cool Tone 200**
Texture:	**Matte watercolor**
Weight:	**200 gsm**
Base:	**100% cotton rag**
ICC profile:	**inkpresspaper.com**
Inkset:	**Matte black**
Media type:	**Enhanced Matte**
Resolution:	**1440 dpi**
Expert tips:	**Double-sided media, ideal for bookbinding**

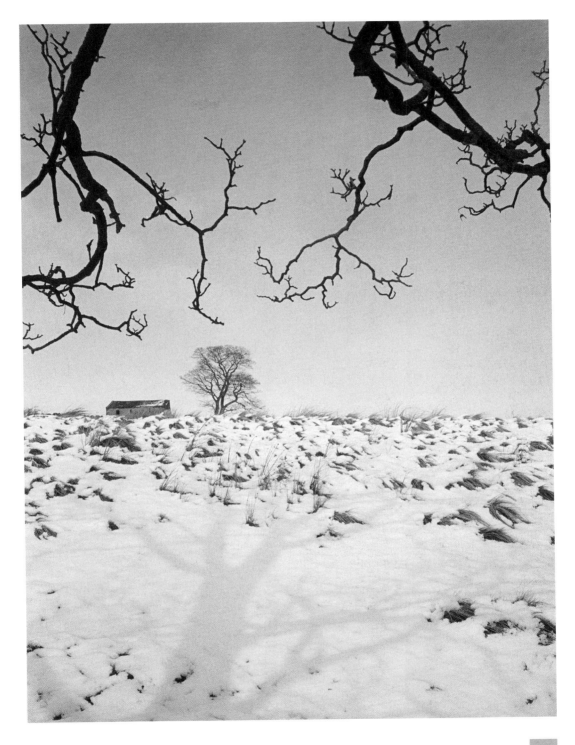

Selenium toning

This process mimics the chemical coloring technique favored by Ansel Adams for creating richly toned landscape prints.

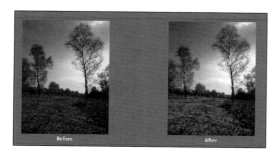

1 Convert to Black and White

Start by selecting Enhance > Convert to Black and White, as shown above. Ensure that the monochrome version still retains some contrast, without any large areas of white highlights, as these low-contrast areas will not accept the following tone colors correctly.

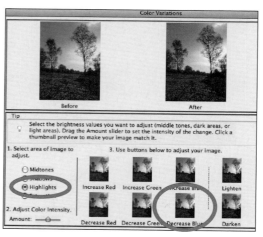

2 Color the highlights

In the Color Variations dialog, select Highlights, then click the Decrease Blue thumbnail to make the lighter tones yellow.

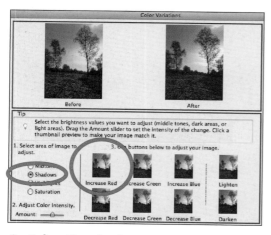

3 Color the shadows

Next, select Shadows, then click the Increase Red thumbnail to make the darker tones redder. The image now looks warm in tone.

Media and printer settings

Brand:	**ILFORD**
Product:	**Galerie Gold**
Texture:	**Fiber Silk**
Weight:	**310 gsm**
Base:	**Baryta fiber based**
ICC profile:	**www.ilford.com**
Inkset:	**Matte black**
Media type:	**Premium semigloss**
Resolution:	**1440 dpi**
Expert tips:	**Designed for use with pigment inks**

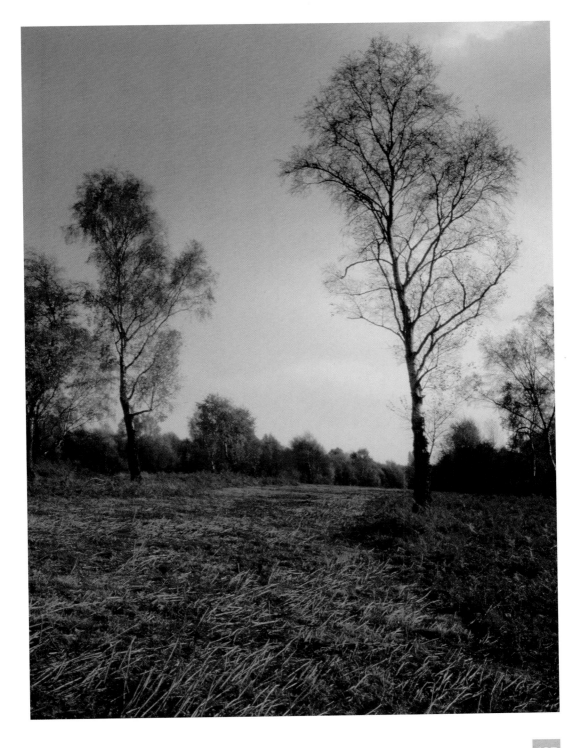

Lith printing

One of the darkest arts of the darkroom, the lith print—with its unmistakable look—is much easier to create digitally.

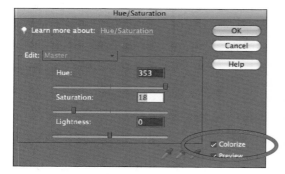

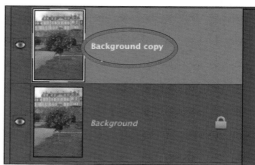

1 Making it pink

A lith print is typified by its unusual pinkish orange color, mixed with high- and low-contrast areas. To start, open the Hue/Saturation dialog and choose the Colorize option. Next, set Hue to 353 and Saturation to 18, as shown above.

2 Making the split contrast layers

The next move is to split the image into two layers so the two contrast effects can be created independently. From the Layers menu, choose the Background layer as shown. Select the copy layer to receive the next edit.

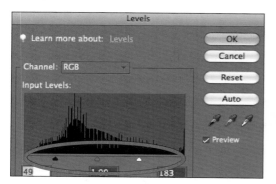

3 Making the high-contrast layer

In the Input Levels section of the dialog, pull both highlight and shadow sliders toward the center, as shown above. This will increase the bright whites and solid blacks in the image.

4 Making the low-contrast layer

Next, select the Background layer (bottom of the Layers palette) and open the Levels. This time, pull the Output Levels highlights and shadow sliders to the center, as shown above. This creates a low-contrast layer.

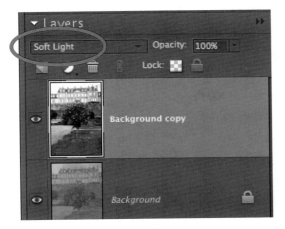

5 Blending high and low together

The final step is to merge the effects of the two layers by using a blending mode. Select the copy layer, then pick the Soft Light blending mode, as shown above.

Media and printer settings

Brand:	Harman
Product:	**Matte FB Mp**
Texture:	Smooth Matte
Weight:	310 gsm
Base:	Baryta fiber base
ICC profile:	harman-inkjet.com
Inkset:	Matte black
Media type:	**Watercolor paper**
Resolution:	1440 dpi
Expert tips:	Avoid handling the coated side

Before

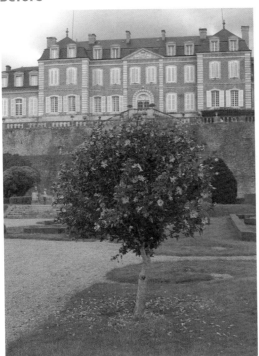

After

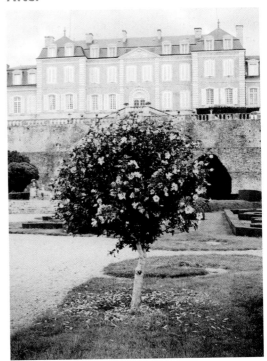

Albumen printing

The red-toned Victorian albumen print is present in most family photo albums, and is simple to re-create with an unusual edit.

1 Skin tone adjuster

The albumen effect is best created using Elements' excellent skin tone adjuster. Drain the color away first using the Remove Color command, then launch the Adjust Color for Skin Tone dialog, as shown above.

2 Click into your image

Move the dialog so you can see the whole image and then float the cursor over your image. Click and watch it turn a warm orange color.

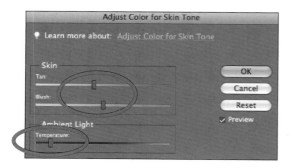

3 Modify the color and tones

There are three sliders in the dialog: Tan, which presents a color range from yellow to brown; Blush, which is a saturation-type tool; and Temperature, which provides either a warming or a cooling effect. The albumen effect was created with the mix above.

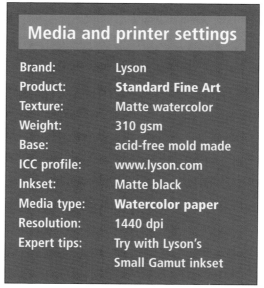

Media and printer settings

Brand:	Lyson
Product:	**Standard Fine Art**
Texture:	Matte watercolor
Weight:	310 gsm
Base:	acid-free mold made
ICC profile:	www.lyson.com
Inkset:	Matte black
Media type:	**Watercolor paper**
Resolution:	1440 dpi
Expert tips:	Try with Lyson's Small Gamut inkset

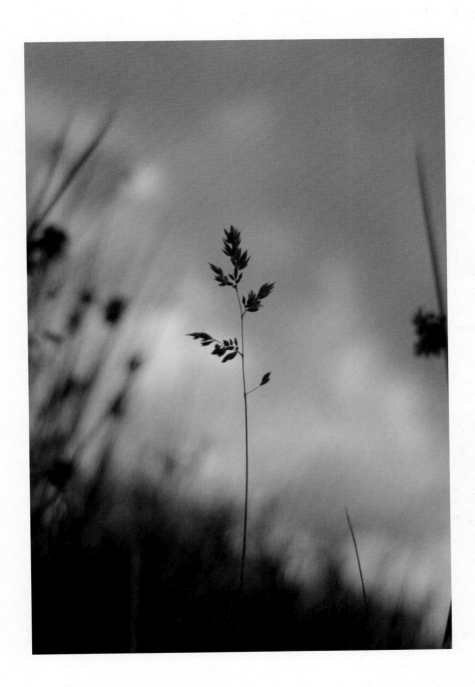

8

Edge styles

Edge essentials

Creating edges and borders involves changing the size, shape, and content of your background layer.

Understanding Image Size

When the image file you are working with is too small for your needs, enlarge it using the Image Size dialog. In this process, newly created pixels are squeezed in between existing pixels. Elements uses a clever routine to estimate the color of these new pixels based on an average of the surrounding pixel color, and the results are pretty impressive.

Image Size adjustments increase the pixel dimensions of an image so it can be printed at a greater size, but the changes won't create any additional space around the edge to introduce artwork or other frame designs.

The downside of enlarging

Enlarging with the Image Size controls is almost imperceptible if you keep it below a 20% increase. However, any more than this and you will start to lose sharpness, as shown above. The file gets bigger, but it isn't any sharper.

Understanding Canvas Size

Elements' Canvas Size functions also allow you to increase the pixel dimensions of the image file, but in a different way. For some editing projects, you will want to introduce additional blank space around your original image for a decorative edge or caption.

The Canvas Size dialog keeps your image at its original pixel dimensions, but adds new pixels around the edge for you to use. By default, Elements fills in this new territory with the current background color in the toolbox. The Canvas Size controls are also used if you want to place two images side by side on the same printout, or if you want to create a montage using different-sized images and graphics.

Never use Canvas Size for enlarging an image, but only for creating empty space around the perimeter.

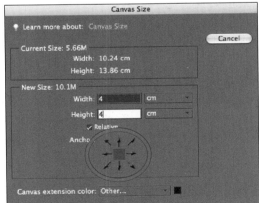

Using the Anchor tool

The Anchor tool in Canvas Size defines the edge from which the new space is created. When set in the center, as shown above bottom, the Anchor tool adjustments add extra space equally to all sides, as seen above top.

Borders

Using thin black borders is an effective way to contain bright skies— and looks great when combined with graphic compositions.

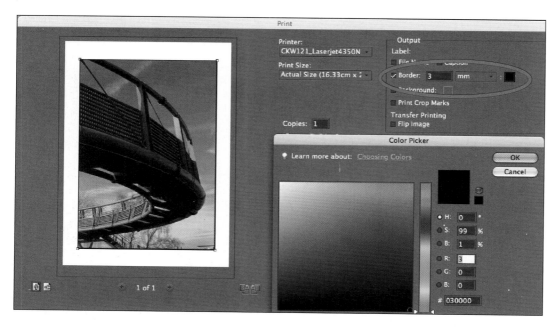

Using the Print dialog

The best way of introducing a black border around your image is to use the Print dialog. Rather than embedding the line into your file forever, this technique temporarily adds the effect and does not apply it to the file itself.

After preparing your file for printing, select File > Print. Under the Output section, click the Border option, as shown above right. Type in 3mm as the width, and then click the color square to choose the border color. For this example, I chose black in the Color Picker. The effect immediately appears around your image in the preview window so that you can check it before sending the file to print.

Using Elements' Stroke function

Choose Select > Select All, then pick Stroke (Outline Selection) from the Edit menu. Define the width and color, as shown above, then print. Unlike the previous method, this process embeds colored pixels into your file.

Mountboard edges

The simplest way to make an edge is by using Elements' Canvas Size controls and two complementary colors sampled from your image.

1 Select a new background color

Elements' Canvas Size tool is used for creating additional space around your image in the current background color. Select a cream color from the Color Picker, as shown, or click to sample a color from your image.

2 Define the inner border size

Select Image > Canvas Size, then increase both width and height by 2cm, as shown. Make sure that the Relative option is selected and the Anchor is in the center. Click OK.

3 Define the outer border size

Go back to the Color Picker and change the background color to a rich brown. Next, repeat Step 2, but this time increase width and height by 4cm, as shown above, and click OK.

Media and printer settings

Brand:	Innova
Product:	FibaPrint
Texture:	Ultra Smooth Gloss
Weight:	285 gsm
Base:	Fiber-based
ICC profile:	www.innovaart.com
Inkset:	Photo black
Media type:	Premium semigloss
Resolution:	1440 dpi
Expert tips:	High-dynamic range media

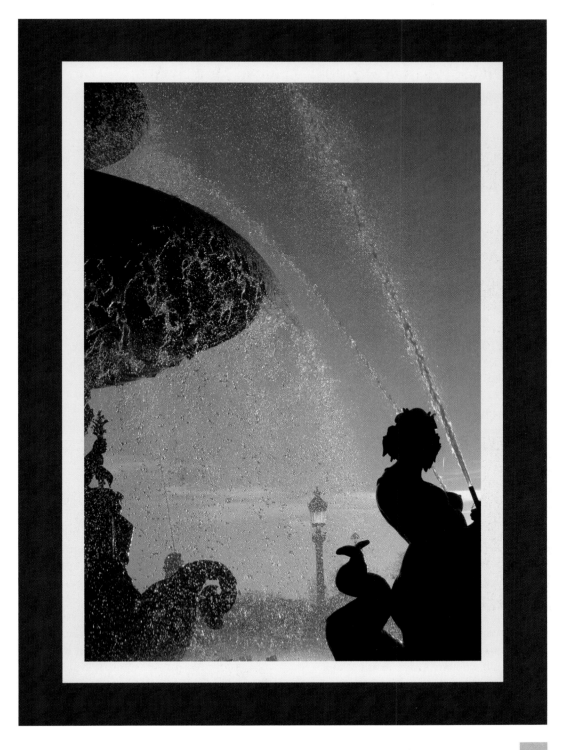

Watercolor style

PhotoFrame Pro is an easy-to-use plug-in for Elements, helping you make signature-style edges around your photographs.

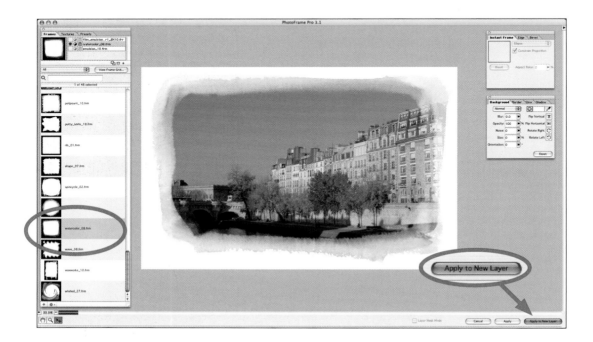

How it works

PhotoFrame Pro is an exciting plug-in designed to add extra creative functionality to Elements. Once installed, PhotoFrame is accessed directly inside Elements through a brand-new menu, so you don't have to swap your file between applications. Open an image file, then select PhotoFrame from the onOne menu, as shown above. Your image will now occupy a new window, with the all-important Frames menu on the left-hand edge, as shown above. PhotoFrame is packed with hundreds of edge styles for you to try or adapt to fit your needs.

1 Choose the frame

Start by selecting a style from the thumbnail menu, as shown above. For this kind of effect, the watercolor frame file is used to create a distressed-style edge. As with layers, you can fade and blend the different frame styles with your image and even apply a color. Multiple frames can also be applied on top of each other, but the best results are achieved if the frame visually enhances the image, rather than distracting from the effect you are trying to create. When finished, click the Apply to New Layer button, as shown above, to keep your design separate from the Background layer.

2 Fine-tuning

Frame edges initially appear around your image with transform-style handles, as shown above. Pull or push these handles to include more or less of your image inside the frame.

Media and printer settings

Brand:	Somerset
Product:	**Velvet Enhanced**
Texture:	Matte watercolor
Weight:	255 gsm
Base:	100% archival cotton
ICC profile:	www.inveresk.co.uk
Inkset:	Matte black
Media type:	**Smooth Fine Art**
Resolution:	1440 dpi
Expert tips:	**Switch High Speed off**
	Increase Saturation

Brushed edges

A stiff paintbrush, some black ink, and a sheet of copier paper is all you need to create a unique edge for your image.

1 Scan your edge design

Make a brushy black shape on a sheet of paper and, when dry, lay it face down in your flatbed scanner. Scan in the Lineart mode at 300 ppi, as shown above.

2 Open in Elements

Open your scan in RGB mode, then click the Magic Wand tool in the black area. Next, choose Select > Similar to ensure all black pixels are included in the selection.

3 Combine the two

Open your image, select it to make it the active window, then choose Select > All. Now make the image with the brushed edge the active window, then select Edit > Paste Into. Use the transform handles to pull it into the desired shape, as shown above.

Media and printer settings

Brand:	**Bockingford**
Product:	**Inkjet**
Texture:	**Watercolor**
Weight:	**190 gsm**
Base:	**100% archival cotton**
ICC profile:	**www.inveresk.co.uk**
Inkset:	**Matte black**
Media type:	**Smooth Fine Art**
Resolution:	**1440 dpi**
Expert tips:	**Coated on both sides, ideal for bookbinding**

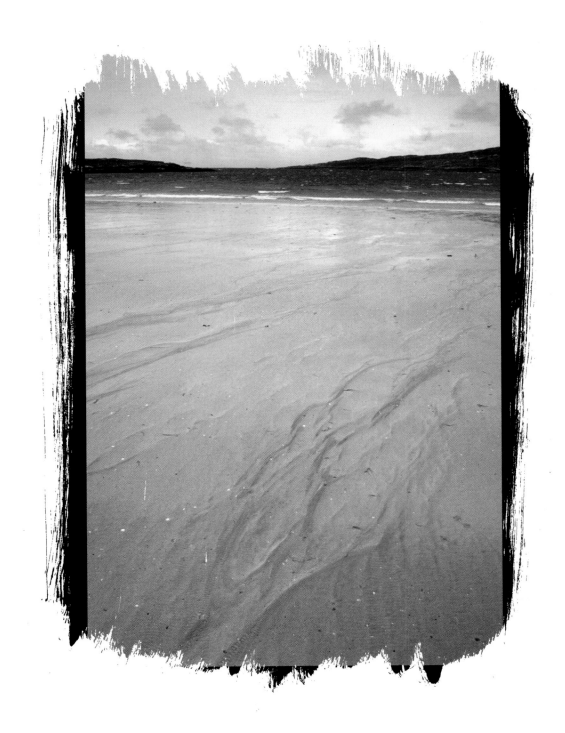

Polaroid Type 55

The famous peel-apart film material is no longer manufactured, but you can still find digital examples of this edge effect to use.

1 Choose a source file

iStockphoto.com is a good place to search for a downloadable digital Type 55 edge, as shown above. The service is low-cost and for a few dollars, you've got a ready-made file to use in your project.

2 Open in Elements

Open the downloaded JPEG file in Elements, then drag the rectangular marquee tool from corner to corner inside the center of the frame. Select Edit > Cut to remove any stray pixels from the center.

3 Paste in and resize to fit

Open your source image and paste it into the edge file, using the transform handles to pull the image to the edges.

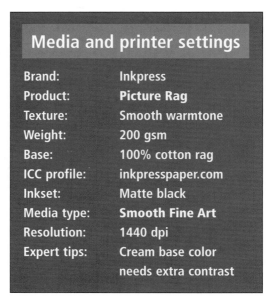

Media and printer settings

Brand:	Inkpress
Product:	**Picture Rag**
Texture:	Smooth warmtone
Weight:	200 gsm
Base:	100% cotton rag
ICC profile:	inkpresspaper.com
Inkset:	Matte black
Media type:	**Smooth Fine Art**
Resolution:	1440 dpi
Expert tips:	Cream base color needs extra contrast

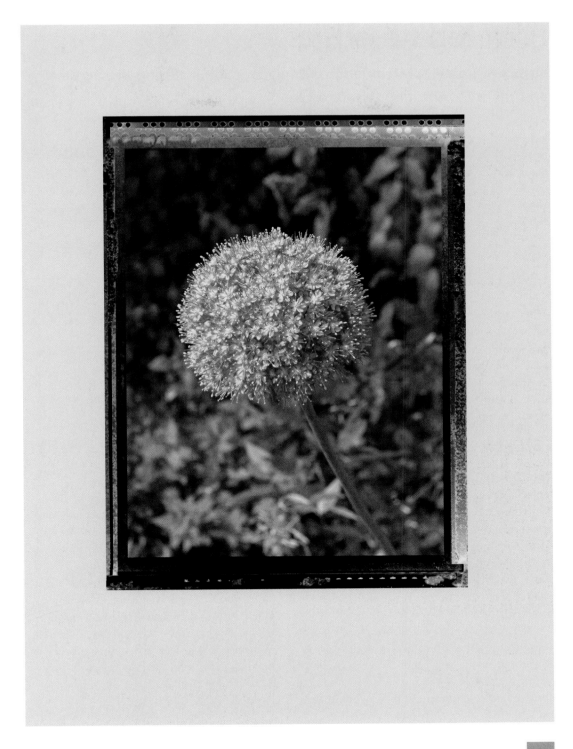

Film rebate edges

Sprocket holes, scratchy edges, and film code lettering are all part and parcel of the film rebate look.

Multiple-edge frames

This effect is created using the PhotoFrame Pro plug-in, but instead of using a single frame file, this project merges two together. From the onOne menu, open PhotoFrame to reveal your image in the standalone window. Next, load the Film 35 edge together with the Camera 02 edge into the Frames palette, as shown above.

When combining two or more frames into one effect, it's important to choose designs that complement each other rather than competing designs. If you're not sure which ones to use, load several frames, then switch them on and off to judge their effectiveness.

Cropping

The beauty of using a plug-in like Photo-Frame is that while you will lose some of your image's peripheral area, you don't have to adjust your canvas size to make space for the effect.

Applying a surrounding frame can help to hide unwanted details and can even provide a fence around distracting elements in the image. The example shown above is a detail captured from a sleek and shiny high-rise building that is enhanced by the addition of a scratchy, jagged edge.

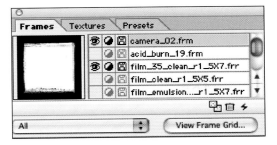

PhotoFrame layers

Just like individual layers in Elements, multiple PhotoFrame edge files can be stacked on top of each other, then switched on and off (as shown above by the eye icons) until the correct balance is achieved. The finished result, shown below, adds a hand-processed feel to an otherwise ordinary shot.

Media and printer settings

Brand:	Lumijet
Product:	**Photo White Pearl**
Texture:	Silk pearl
Weight:	260 gsm
Base:	100% alpha cellulose
ICC profile:	www.lumijet.com
Inkset:	Matte black
Media type:	**Smooth Fine Art**
Resolution:	1440 dpi
Expert tips:	**Produces saturated color**

Cutouts

A cluttered or distracting background can detract from the main subject of your image—but can easily be removed.

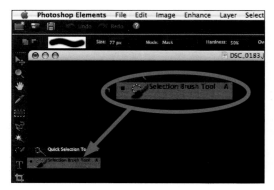

1 Choose the Selection Brush tool

Cutouts are best made with Elements' Selection Brush, used in the Mask mode, as shown above. Set the brush between 80 and 100 pixels in size and with a 50% hardness so that the cut edges remain soft.

2 Paint in the mask

Rather than select the unwanted background, use the brush to paint over the areas you want to keep. The Selection Brush marks the protected area with a nonprinting red color, as shown above.

3 Cut out the background

Once you have applied a mask to the figure, change tools to reveal the selection edge you have created. Next choose Select > Inverse, then Edit > Cut to turn the unwanted background area into pure white.

Media and printer settings	
Brand:	**Hahnemühle**
Product:	**Torchon**
Texture:	**Pastel watercolor**
Weight:	**285 gsm**
Base:	**100% alpha cellulose**
ICC profile:	**Hahnemuehle.com**
Inkset:	**Matte black**
Media type:	**Smooth Fine Art**
Resolution:	**1440 dpi**
Expert tips:	**Makes excellent greeting cards**

9

Custom prints

Shape essentials

The techniques in this chapter create custom-sized inkjet prints, all of which need trimming.

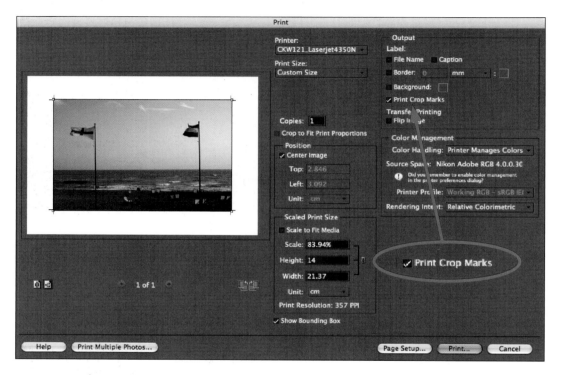

The truth about trimming

Trimming photographic prints can cause a lot of anxiety, especially if you've put a great deal of effort into making a one-off print. Never trim prints with scissors or a blade and ruler combination, as it's far too easy to slip and ruin the symmetry of your print.

The best way to finish off a print is to use a purpose-made rotary trimmer, preferably one with a built-in rule or scale. Never cut more than one print at a time and always clean before use, as tiny grains of sand or grit under the guides will scratch the ink off your print.

Make life easier with crop marks

If you want to make trimming even easier, then use the Print Crop Marks function in Elements' Print dialog, as shown above. When selected, the Print Crop Marks option creates four tiny crosshairs at the corners of your image when printed.

When you line up your print in the trimmer, the crosshairs show you where to start and stop cutting so you don't have to guess. The marks are not embedded into your image file and print in black.

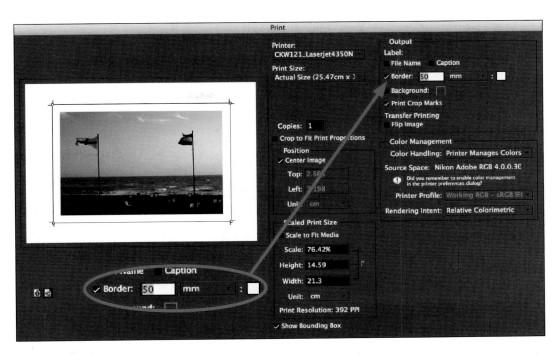

White bordered print with crop marks

Not all of your print projects will be made for letter-sized paper, so if you want to print out a specially sized image on a larger sheet of paper, as shown above, you need to use a combination of the Border and Print Crop Marks commands. In the Print dialog, arrange the image using the Bounding Box function. Next, select Print Crop Marks, then set the Border value to 50cm (the maximum size possible), and pick white as the color. The crop marks are placed far enough away from the edge of your image to serve as useful trimming guides.

Using a background color

If you have blank space around your image, you can color it with the Background function. The example shown right uses a cream shade selected from the Color Picker.

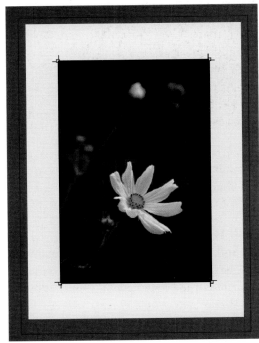

Making a contact print

The most convenient way to reflect on all the images from a day's shoot is to print them out as a contact print.

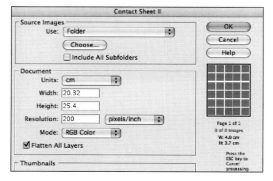

1 Organize your shoot

Start by transferring your images from your camera to your hard drive. The example above shows a day's shoot in the browser application, Bridge. To make a contact print, you must place all your source images in the same folder.

2 Using Contact Sheet II

Open Elements and select File > Contact Sheet II. In the Source Images panel, select Folder and click Choose to point Elements to the desired set of images. Next, define the paper size and set Resolution to 200 ppi.

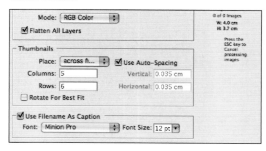

3 Defining the layout

In the Thumbnails panel, choose 5 columns and 6 rows to define how many images print out per page. At this size, the thumbnails are big enough to evaluate properly. Deselect Rotate For Best Fit, as this prints portrait-format shots too small to see. Finally, select Use Filename As Caption and set Font Size to 12 pt.

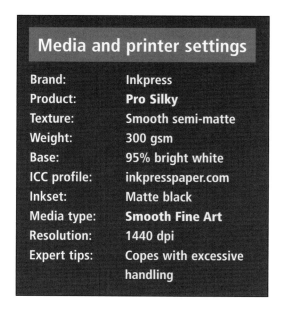

Media and printer settings

Brand:	Inkpress
Product:	**Pro Silky**
Texture:	**Smooth semi-matte**
Weight:	**300 gsm**
Base:	**95% bright white**
ICC profile:	inkpresspaper.com
Inkset:	**Matte black**
Media type:	**Smooth Fine Art**
Resolution:	1440 dpi
Expert tips:	**Copes with excessive handling**

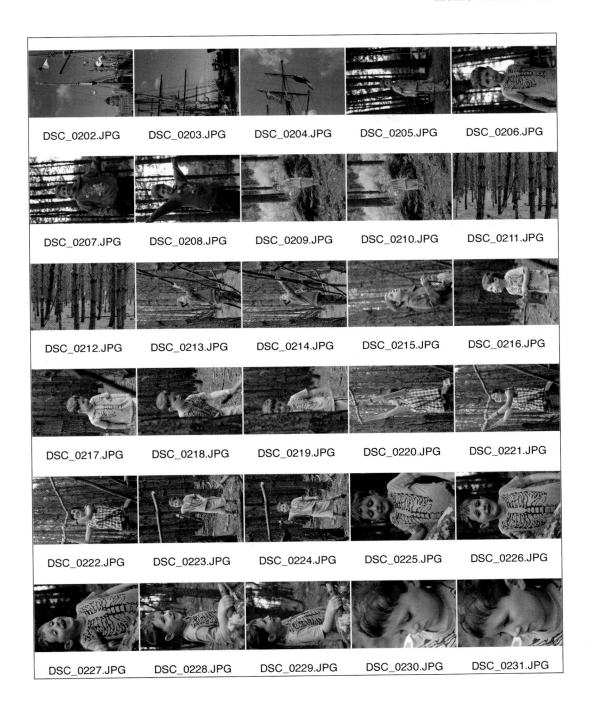

Using Picture Package

The simplest way to make multiple copies of your favorite image on a single sheet is with the automated Picture Package function.

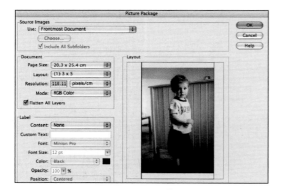

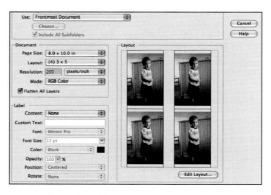

1 Choose your image file

Open your chosen file in Elements, then select File > Picture Package. Set the size of your printing paper in the document panel, as shown above.

2 Define the layout

In the Layout menu, choose the quantity and size of the package you want to build. The example above tiles the image four times on the chosen paper size at 3"×5". Set Resolution to 200 ppi for inkjet output.

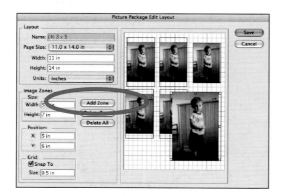

Edit the Layout option

If you want to use a specific layout not offered by Elements' preset sizes, select the Edit Layout button (shown in step 2). Now you can resize the images and paste in additional copies using the Add Zone button.

Media and printer settings

Brand:	Innova
Product:	FibaPrint **White Matte**
Texture:	Smooth matte
Weight:	285 gsm
Base:	Fiber based
ICC profile:	innovaart.com
Inkset:	Matte black
Media type:	**Smooth Fine Art**
Resolution:	1440 dpi
Expert tips:	**Scratch resistant and good for trimming**

Printing captions

There's no need to use a desktop publishing application for adding text to your image; you can use the File Info command instead.

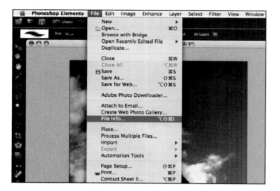

1 Dig deep into the File Info

Largely unnoticed in both Elements and Photoshop is the File Info dialog. Open the file you want to print, then select File > File Info, as shown above.

2 Fill in the text fields

Select the Description tab and enter text in the four fields, as shown above. The Caption field is the all-important one for this project, as the words you enter here will print underneath your image. All File Info text is saved when you resave the image.

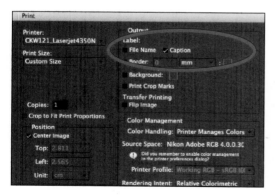

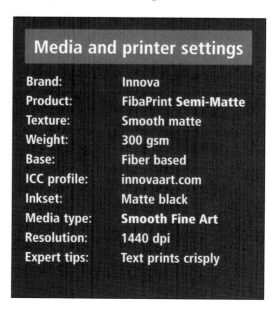

3 Link the caption to the print

Next, select File > Print and in the Output panel, choose the Caption option, as shown above. The text from the File Info dialog will be centered under your image, providing there is empty space on the paper.

Media and printer settings

Brand:	Innova
Product:	FibaPrint **Semi-Matte**
Texture:	Smooth matte
Weight:	300 gsm
Base:	Fiber based
ICC profile:	innovaart.com
Inkset:	Matte black
Media type:	**Smooth Fine Art**
Resolution:	1440 dpi
Expert tips:	Text prints crisply

Achill Island

Making watermarked proof prints

If you are providing proof prints free of charge, protect against unauthorized copying with a watermark.

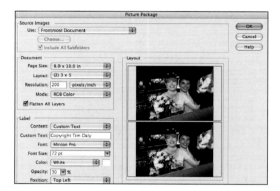

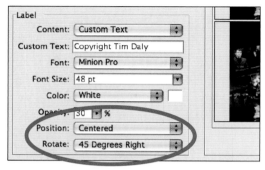

1 Using the Label functions

Open your image and launch the Picture Package dialog. In the Label panel, found at the bottom left of the dialog, choose the Custom Text option. Set the size, color, and opacity as shown above.

2 Positioning the watermark

It's essential to place the watermark in exactly the right position. If it doesn't drape across the main subject, there's a chance it will be cut off or cropped by an unscrupulous client. Experiment with the Rotate and Position options, as shown above.

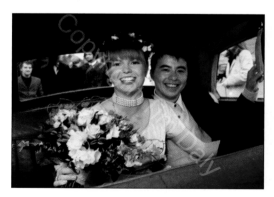

3 Reviewing the position

Set with a 30% opacity, this white watermark conveys its purpose, but placed across the bride's face, is poorly positioned. The final print, shown right, doesn't block the face, but clearly states the message.

Media and printer settings

Brand:	**ILFORD**
Product:	**Galerie Classic**
Texture:	**Pearl**
Weight:	**250 gsm**
Base:	**Resin coated**
ICC profile:	**www.ilford.com**
Inkset:	**Matte black**
Media type:	**Smooth Fine Art**
Resolution:	**1440 dpi**
Expert tips:	**Not compatible with pigment inks**

Panoramic style

Many landscape images look even better when cropped to a letterbox panoramic shape.

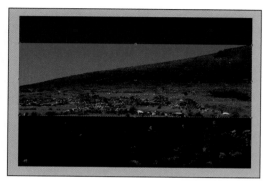

1 Starting point

The example image shown above is a clumsy composition with too many distracting elements. The intended subject is a thin row of derelict cottages, but the foreground grabs all of the attention and emphasis.

2 Crop to the new shape

Select the Crop tool and drag this across your image. All unwanted areas darken and sit outside the dotted selection line. This crop, as shown above, places the emphasis back onto the original subject.

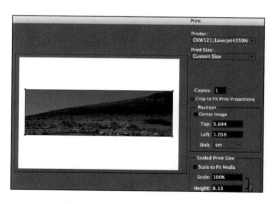

3 Print the panoramic file

When the crop is complete, arrange the image into the center of your intended paper size, as shown above. Three striking examples of a panoramic print are shown on the opposite page.

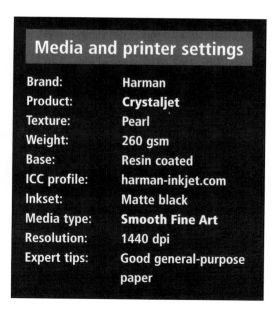

Media and printer settings

Brand:	**Harman**
Product:	**Crystaljet**
Texture:	**Pearl**
Weight:	**260 gsm**
Base:	**Resin coated**
ICC profile:	**harman-inkjet.com**
Inkset:	**Matte black**
Media type:	**Smooth Fine Art**
Resolution:	**1440 dpi**
Expert tips:	**Good general-purpose paper**

Greeting cards

Many paper manufacturers provide top-quality prefolded cards for making your own greeting cards at home.

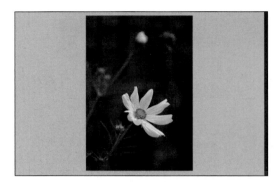

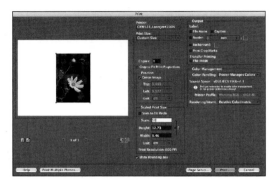

1 Get your image into shape

Make all the creative edits to your file before thinking about the printing stage. Ensure that your image is in proportion to your chosen card, using the Crop tool to shave bits off if necessary.

2 Set the paper size

In the Print dialog, choose the overall size of the unfolded card. To account for the fold in the center of the card, it's essential to move the image to one side of the sheet.

3 Drag the bounding box

Deselect the Center Image option first, then select Show Bounding Box. Now, drag the image to the right-hand side of the preview, as shown above. This now makes space for the fold line.

Media and printer settings

Brand:	**Moab**
Product:	**White Entrada 5"×7"**
Texture:	**Matte watercolor**
Weight:	**190 gsm**
Base:	**100% archival cotton**
ICC profile:	**moabpaper.com**
Inkset:	**Matte black**
Media type:	**Smooth Fine Art**
Resolution:	**1440 dpi**
Expert tips:	**Can print on both sides**

10

Creative media

Printing essentials

Printing onto unconventional media can set your work apart from the crowd, providing you accept a few limitations.

Use correct media setting

When you're using thick paper, it's important to check that it's compatible with your printer. All printers have a media setting lever, shown above, which must be matched with the media type to avoid damaging the printheads.

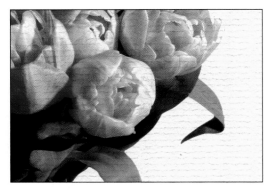

Texture showing through

One of the most interesting aspects of using alternative paper is texture. The example above was printed on high-quality writing paper, with its laid texture visible in the final print.

Colored highlights

You won't see pure white highlights anymore, but only the base color of the paper showing through. The example above was printed on a buff colored paper, creating a vintage-style varnished effect.

Lower sharpness

You'll never match the pin-sharp results of glossy inkjet media when using art papers, but the softer end result can be visually pleasing. The example on the facing page was printed on Indian handmade paper.

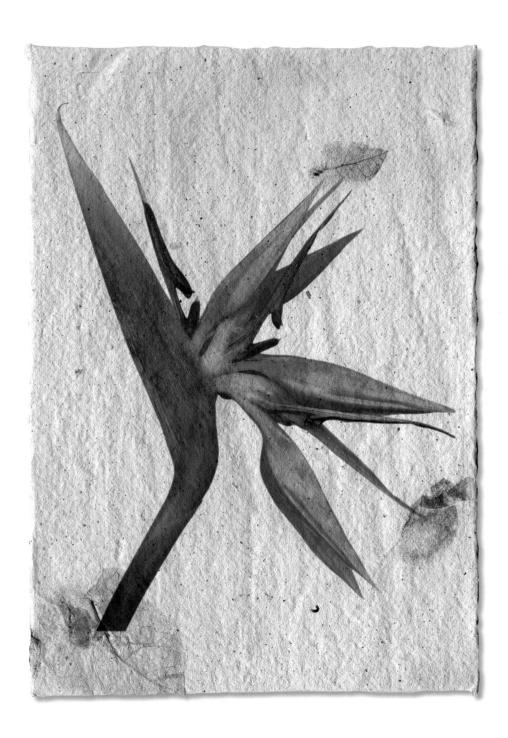

Inkjet transfer

Great for creating one-off prints on art paper, inkjet transfers are simple to make but highly unpredictable.

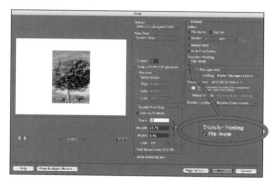

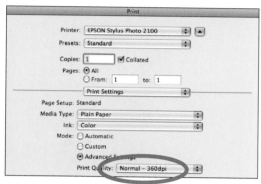

1 Flip your image

Prepare your image for printing, and then select File > Print. Scale and orient the image; then select the Flip Image option, as shown. This laterally reverses the image so it prints the right way after transfer.

2 Prepare the Print dialog

Achieve the best results with clear film media and a low Print Quality setting such as 360 dpi, as shown. Any higher and too much ink will be placed on the film, resulting in muddy, unsharp prints.

3 Transfer to receiving paper

After the film is ejected by your printer, place it face down on the receiving paper and press with a rubber roller. Achieve the sharpest results by rolling the transfer image onto inkjet paper.

Media and printer settings

Brand:	PermaJet
Product:	**Digital transfer film**
Texture:	Clear film
Weight:	165 microns
Base:	Ceramic-coated acrylic
ICC profile:	www.permajet.com
Inkset:	Photo black
Media type:	**Photo Quality Inkjet**
Resolution:	360 dpi
Expert tips:	Use uncoated side for transfer printing

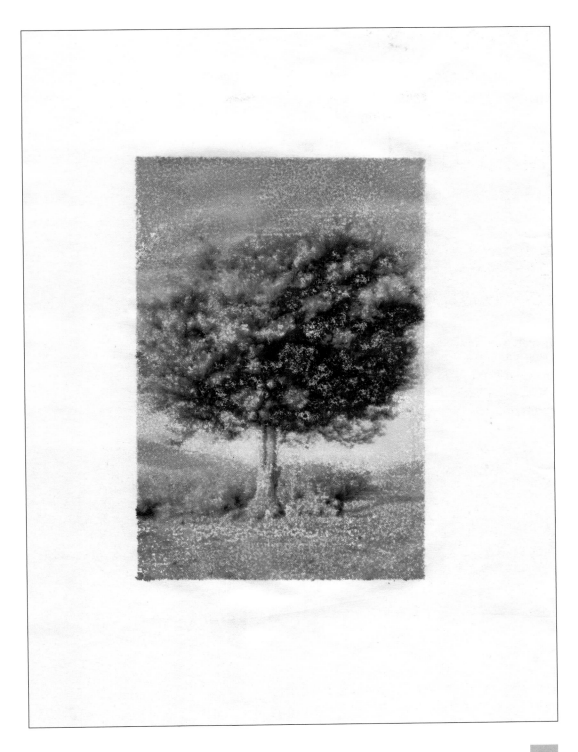

Colored papers

Writing papers can add a vintage or eye-catching effect to your prints and, despite the absence of profiles, are very easy to use.

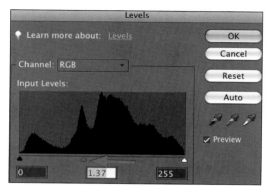

1 Choose your media

The most important thing to remember when using nonwhite media is that the overall color of your chosen paper becomes the maximum highlight value of your print. There's no such thing as white ink!

2 Adjust image brightness

If you've chosen a midtone paper, you'll need to increase the overall brightness of your image to compensate for darker highlights. Open the Levels dialog and move the mid-tone slider as shown above.

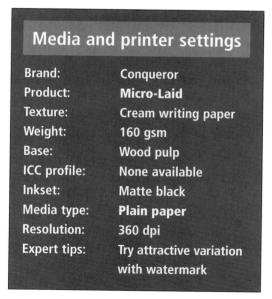

3 Judge the test print

When ink is applied to colored paper, the base color will affect the overall color balance. Make a test print and then use the Color Variations dialog to remove any casts.

Media and printer settings

Brand:	Conqueror
Product:	**Micro-Laid**
Texture:	Cream writing paper
Weight:	160 gsm
Base:	Wood pulp
ICC profile:	None available
Inkset:	Matte black
Media type:	**Plain paper**
Resolution:	360 dpi
Expert tips:	Try attractive variation with watermark

Canvas

Printing on canvas is much easier than it sounds, with many specially prepared products now on the market.

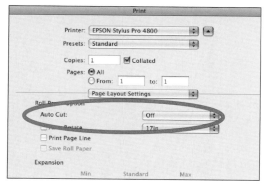

1 Cut to size

It's more economical to buy canvas on a roll, and you can cut it to size or use it in a printer with a roller transport. Use a craft knife to cut the canvas, allowing extra space for later mounting on a wooden stretcher.

2 Turn off Auto Cut

If your printer has a built-in cutter, make sure that it's switched off before using canvas. Cutters are not designed for slicing cloth and are easily broken. Select Off from the Auto Cut drop-down in the Print dialog as above.

3 Cure the canvas

Although coated canvas prints are virtually dry once ejected, it's a good idea to let the ink cure for 24 hours before mounting or coating. To speed this up, place a blank sheet of paper over the print while it's curing.

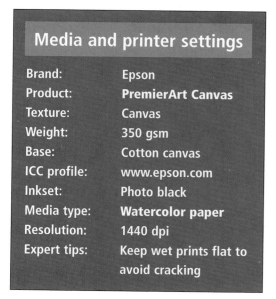

Media and printer settings

Brand:	Epson
Product:	**PremierArt Canvas**
Texture:	Canvas
Weight:	350 gsm
Base:	Cotton canvas
ICC profile:	www.epson.com
Inkset:	Photo black
Media type:	**Watercolor paper**
Resolution:	1440 dpi
Expert tips:	**Keep wet prints flat to avoid cracking**

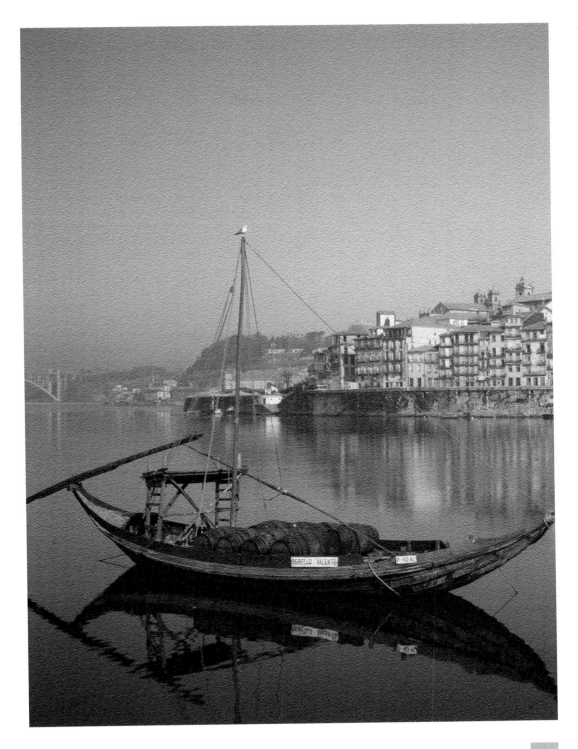

Iron-on transfer media

Great fun for making customized t-shirts, iron-on transfer media is washable and easy to use.

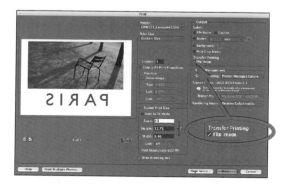

1 Design your transfer

All white areas of your image become transparent when printed onto your chosen fabric. Like colored paper, the actual color of the fabric becomes the maximum highlight of the transfer, so avoid darker colors.

2 Print out in reverse

As the transfer paper is pressed face down on the fabric, the image needs to be reversed before printing. In the Print dialog, choose the Flip Image option as shown.

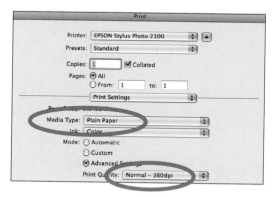

3 Choose correct media setting

Most transfer media can cope with only a few fine ink dots, so use Plain Paper with a 360 dpi setting. Although these dots are visible on your print, they are much less noticeable when transferred to fabric.

4 Iron on the transfer

Trim off any excess transfer paper from around your image or design, then place the paper face down on your fabric. Run a hot iron across the back, ensuring the corners are well pressed down.

5 Peel off backing paper

Lift a corner of the backing paper to check that the heat applied is sufficient to bond the transfer paper to the fabric. If it isn't, replace the paper and apply the iron again. The final result, shown below, is a unique one-off garment that can be worn and washed like any other t-shirt.

Media and printer settings

Brand:	Epson
Product:	**Iron-on transfer**
Texture:	Glossy film
Weight:	210 gsm
Base:	Clear film
ICC profile:	www.epson.com
Inkset:	Photo black
Media type:	**Plain paper**
Resolution:	360 dpi
Expert tips:	Check for printer compatibility before use

Uncoated papers

With low contrast and a soft reproduction, uncoated papers provide a unique backdrop for special projects.

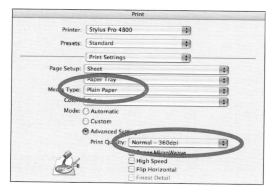

1 Steering the print driver

For best results, use the Plain Paper media type setting combined with 360 dpi print quality. This puts fewer dots of ink on the paper, so they don't bleed into each other.

2 Judging the test print

The example above is a typical test print with lower than expected saturation, resulting in a blurry, washed-out print. This is due to the increased absorbency of the uncoated paper and the off-white base.

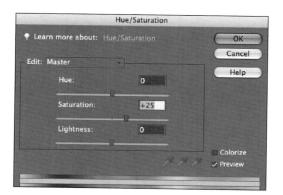

3 Boosting color saturation

To enhance the vibrancy of the print, try increasing the saturation using the Hue/Saturation dialog. The final result, shown on the facing page, looks more vivid than Step 2.

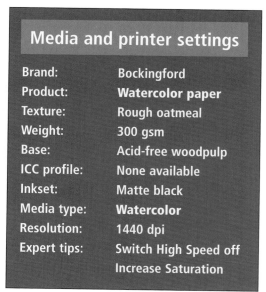

Media and printer settings

Brand:	Bockingford
Product:	**Watercolor paper**
Texture:	Rough oatmeal
Weight:	300 gsm
Base:	Acid-free woodpulp
ICC profile:	None available
Inkset:	Matte black
Media type:	**Watercolor**
Resolution:	1440 dpi
Expert tips:	**Switch High Speed off**
	Increase Saturation

InkAid coating

This special brush-on medium enables you to prepare unusual materials such as wood and cardboard for inkjet printing.

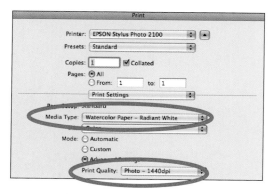

2 Experiment with printer settings

High-quality prints result from carefully applied coating and plenty of experimenting with different printer settings. Start by using 1440 dpi with Watercolor or matte paper media settings.

1 Prepare your own media

InkAid Precoat is a liquid inkjet coating ready to brush onto any porous surface to prepare it for printing. There are two types: transparent, which allows the paper color to show through; and white, which doesn't. Apply to your chosen paper with a large, soft brush; let everything dry; and then apply a second coat. On the facing page is a print made on Rosapina paper and InkAid.

Media and printer settings

Brand:	Fabriano
Product:	Rosapina
Texture:	Felt-marked
Weight:	280 gsm
Base:	Acid-free 60% cotton
ICC profile:	None available
Inkset:	Photo black
Media type:	**Watercolor paper**
Resolution:	1440 dpi
Expert tips:	**Keep deckled edge on your final print**

11

Finishing touches

Border colors and mats

A well-chosen colored mat with a complementary-colored frame will enhance the look of your print even further.

Frame and mat colors

Black and white and color photographic prints look best when displayed in a carefully chosen combination of mat and frame. White mats are easy enough to use and look great for both kinds of prints, but neutral midtone colors can look good too. Toned black and white prints, like the two shown above- and bottom-right, can be greatly enhanced by a dark wood frame and cream- colored mat. This combination makes the warm tone of the print appear richer.

Highly saturated colors are much less useful, as they will interfere with the original color of the image and be even harder to frame.

On the facing page are four colored mats, each subtly changing the look of an identical color print. The darkest mat appears to

increase the print's contrast while the lightest one makes the image colors appear even more vibrant!

Print placement

How you position an image on your chosen paper can truly make or break the final outcome.

Benefits of framing

In addition to enhancing the appearance of your prints, the process of framing actually creates a kind of hermetically sealed environment for your work. Many digital paper prints can be damaged by handling, but more severely so by invisible atmospheric pollutants if kept in the open air.

When framing a print, it's never a good idea to have the print surface touching the glass, as in a clipframe, because this contact point will be susceptible to moisture damage. Always separate the print from the glass with a mat or set the image away from the surface.

The back of the frame is important too, for if you don't seal all around with framing tape, it's an open invitation to all kinds of bugs to climb inside and eat your artwork!

Fit to page or print with borders?

On the facing page are four prints produced from an identical image file. Unfortunately, the proportions of a digital sensor don't match the proportions of letter-sized paper, so there are compromises to be made when considering the placement of your image on the paper.

The top-left image shows such a compromise where a portion of the image is cropped off the bottom when it's printed edge-to-edge. This type of print is difficult to mount because there's no extra space on the paper, and even more will be cropped off if it is window-matted. Edge-to-edge prints are much less attractive, resembling mass-produced photo lab prints moreso than fine artworks.

At the top right you'll see the full image, slightly reduced in size to fit the paper. Although now uncropped compared to the previous example, the image still looks a little cramped by the encroaching edges. Much better to add some space between the image and the edge of the paper.

On the bottom are two prints made with an identical-sized image, albeit placed in slightly different positions. The bottom-left image shows a classic optical illusion: although the white borders are equal top and bottom, the image looks as if it has slid slightly downwards. The far-right image shows the same sized print with top, left, and right borders equal, and a deeper bottom border. This is the ideal way to do it!

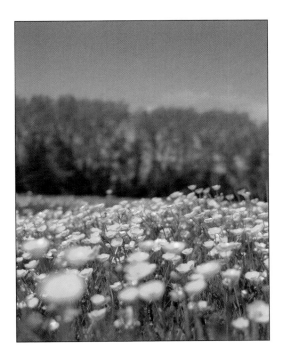

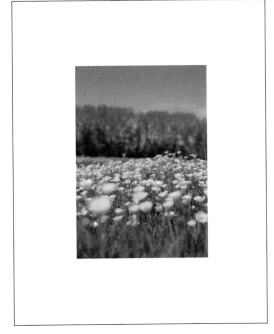

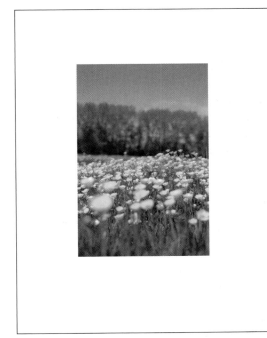

Window matting

The best way to present your photographic prints is with a hand-cut window mat.

Cutting tools

Although window mats are cheap enough to buy ready-made, they rarely fit your print exactly. There are a wide range of cutting tools on the market for this task, including cheaper hand-held units that you use with your own ruler. A much better idea is to cut your own mats with a purpose-made cutter such as the Logan, shown above. Designed with a combined clamp/ruler/knife guide, the Logan provides a stable and accurate method of cutting card stock to fit your print.

www.logangraphic.com

Matting materials

All photographic prints are susceptible to chemical damage, especially that which is caused by low-quality card mats and adhesives. Always use archival-quality mat board as this will prevent chemicals from seeping into your print, which can result in fading. Never use adhesives or adhesive tape to stick your prints onto card stock, as these will, in time, react poorly with ink, permanently damaging your print.

Making a hinged mat

Cut two pieces of archival mat board the same size to fit into your intended frame. Measure your print, then cut a window shape ½" smaller all around. Next, attach the two sheets of card together using a line of tape on the long edge as shown above. Place the print on the bottom sheet, making sure the edges aren't visible when the hinged window is folded on top. Use self-adhesive photo corners to keep the print from moving under the window mat.

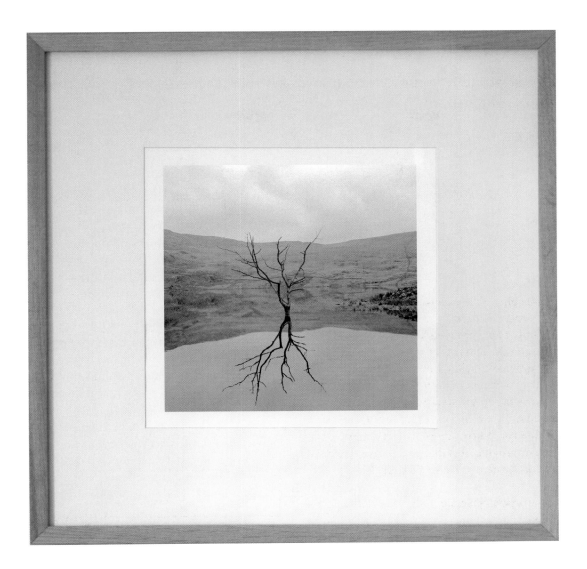

Museum-style matting

In the example above, the image was printed with a generous 2" white border, so you see the edges of the image. The window mat was then cut ½" bigger than the image all around so you can see the printing paper. This is also a good way to include an artist's signature or edition number.

Floating mount

For a completely professional look, try using concealed tape to create an invisible floating mount.

Preparing your print for framing

Although most inkjet paper and ink manufacturers claim their products last for years, you can further futureproof your prints with the use of a protective spray. The Desert Varnish brand, created by Moab, is a widely used product that creates an additional "seal" between your print and the outside world.

Desert Varnish spray works by providing a UV barrier for those images destined for permanent daylight display and also a waterproof coating to protect the print from any liquid hazards. Used with both dye and pigment inks, this lacquer-based spray is best applied in a slow, sweeping motion in a ventilated environment or extraction booth.

In addition to this spray-on coating, Moab also makes a similar product called Desert Varnish gel. As its name suggests, the gel is designed for use on thicker media, including canvas and fine art paper. Applied with a brush, roller, or spray gun, the gel provides a durable gloss finish and protects against physical damage, such as scratches, on your finished prints.

www.moabpaper.com

Linen tape

Preferable to liquid glues or adhesive tape, linen tape is manufactured under strict archival controls. This material is acid-free and won't impart any nasty chemicals onto your artwork, and is used by all the major commercial and public sector art galleries. Linen tape is coated on one side only with a water-based adhesive, which, when moistened (or heated), can be fastened onto the reverse of a print or onto mounting board. Unlike most types of tape, linen tape is easily removed and its effects are completely reversible.

The Lineco brand of linen hinging tape is available in most good art shops or online at:

www.dickblick.com

Making a concealed mounting

To create the effect of a floating mount, shown left, place the print above the backing card so it appears to "float" within the window mat. Next cut four pieces of linen tape, shown above, to about four inches in length.

Now pick up a piece of tape and ensure that the adhesive side is outermost. Bring the two ends together to create a loop. Lick the ends to join them together, and repeat this with the remaining three lengths. Next, flip your print over to view its reverse side. Attach a tape loop in each corner, making sure that it doesn't overlap the print edge and become visible. Lick the loops on one side to attach to the print. When dry, lick the loops and stick onto the backing card.

191

Print storage

After spending time and resources making the perfect print, don't skimp on storage, or your work could get easily damaged.

Ideal storage conditions

Like all paper-based artwork, photographic prints contract in the cold and expand in warm conditions. In addition, airborne moisture also causes prints to shift. Thus prints must never be glued, bonded, or pinned, or displayed in such a way as to restrict movement.

The best way to keep your prints in top condition is to allow constant contraction and expansion in a print storage box. Once kept out of the light, the lifespan of your print can be extended by maintaining a constant temperature, away from atmospheric pollutants and moisture.

Digital prints in general have a much greater chance of lasting longer compared to chemically processed photographic prints, which undergo the "hidden" process of print development and all the associated bleaching, fixing, and washing agents.

Print storage boxes

A great way to store your prints is to use properly designed print storage boxes. Made in all popular print sizes (with at least ½" clearing all around), these are produced from archival-quality card so your prints remain in good condition.

Many photographers opt for further protection by slipping their prints into polyester print sleeves. Polyester is an inert material that protects prints from atmospheric pollutants and provides a useful barrier against physical damage that can occur through handling. These sleeves also provide a super gloss covering that enhances the image.

Storage systems are available to suit a wide range of budgets, starting with simple archival card boxes to handmade rigid print boxes, both offering a secure method of preserving your finished prints. Available to buy at:

www.dickblick.com

One-piece archival print box

This innovative design is made from a single sheet of precut and scored archival card, supplied flat, ready for you to fold into shape. More economic than rigid boxes, this kind of print storage system is favored by many professional photographers and artists.

Rigid print boxes

Many art museums across the globe use rigid print boxes, such as the example at left, to store precious printed images. Made from archival card and the cloth-like buckram covering, these boxes are long-wearing and can be arranged and labeled on shelves for easy indexing.

Presentation function

A clamshell case can also fold out flat so you can use it as an effective presentation tool. With your prints placed in one side, you can quickly show them one by one, stacking them up in the opposite lid.

12

Print services

Photobooks

Blurb's BookSmart is a free application for making your own photobooks, without the need for desktop publishing skills.

Making your book

Like many on-demand printing services, Blurb.com offers its software BookSmart, shown above, for free. BookSmart is primarily aimed at nondesigners and is equipped with plenty of layout tools to help you position both images and text. Once launched, BookSmart prompts you to choose the style and shape of your book, but like all other decisions made in the application, this decision is reversible. BookSmart cleverly enables you to define your source images not only from a local disk or drive, but also from your own online source like Flickr.com. When your source images are identified, they become visible in BookSmart and can be easily dragged and dropped into position on your page.

A book project is essentially divided into two components—the cover and the inside contents—and BookSmart allows you to add, move, and delete individual pages as you work. Each of the two components has a set of predesigned templates, which you can use to provide the layout grid for your book. With so many options to choose from, it pays to experiment with a few before committing to an overall style for your project.

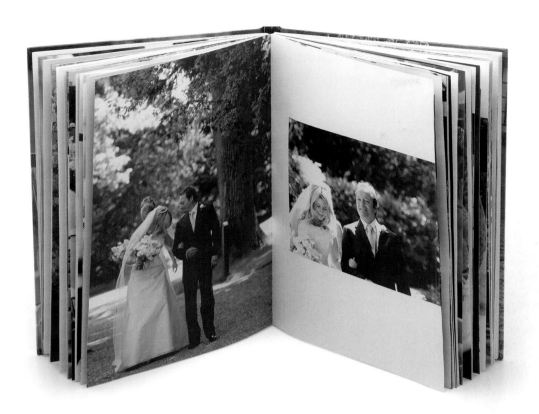

Book ideas and formats

Wedding photographers were the first to embrace the benefits of short-run photobooks by turning large numbers of images into a more memorable end product. These exquisite hardback photobooks, shown above and right, are made by Bobbooks. co.uk.

Photobook service providers

www.blurb.com
www.lulu.com
www.pikto.com

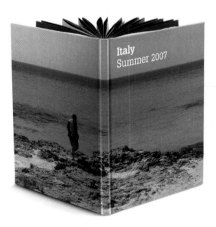

Calendars

You can now design and build you own calendar using an online photo print service.

How it works

A personalized calendar is an excellent gift and a great way to turn your best photographs into a functional item for your family and friends. Lots of online photo labs and on-demand book printers now provide a calendar making service and, best of all, you don't need any desktop publishing skills to make one.

The example shown above right is a calendar made with Lulu.com, one of the easiest services to use and I think the best value around. The key to making a good calendar is the selection of 12 strong images, plus an extra special shot for the cover. Most online services allow you to create your calendar with simple templates, dragging and dropping your images in your chosen layout and sequence. Most calendar formats accept either horizontal- or portrait-format images, but not both at the same time!

Preparation tips

There's rarely any editing assistance provided, so you need to prepare your image files fully before assembly. Save your files at 300ppi and make sure they are in JPEG format (selecting the highest quality option to maintain sharpness, detail, and vibrant color). It's not necessary to prepare your files at exactly the right size; you can usually enlarge or reduce their size within the calendar template.

The Lulu.com service provides a very useful preview function (see facing page) so that you can double-check your layouts before placing an order. With plenty of date and text layout options, the Lulu.com templates allow you to create a personalized end product. Like other online on-demand providers, Lulu.com also acts as an Amazon.com-like reseller, making your projects available for purchase by anyone you choose!

aidan and christy

C-type prints

A low-cost alternative to printing your photographs at home is to print on real photographic paper through an online lab.

Digital C-type prints

Although most good inkjet systems will guarantee your prints will last 80 years or more, there are occasions when you will opt for a chemically processed color print. C-type prints are color photographic prints made using technology that's existed for 50 years or more, but done by beaming digital data onto the paper rather than light from a conventional enlarger. C-type prints are inexpensive and competitively priced compared to inkjet prints, especially at the poster sizes.

Many good online photo labs, such as PhotoBox, shown above, can turn your digital prints into C-type prints. Most offer online file storage and the option to invite guests to view and buy prints directly, so you don't have to administer the ordering. If you have a large number of images from a family event to print, it will be both quicker and cheaper to produce the job through an online lab.

Large-scale professional output

For exhibition and display projects, the superior lightfastness of C-type prints makes them a good option to try. Above the standard paper size of 13"×11", the price of a photo-quality desktop inkjet becomes prohibitive for most budgets. So, it's a good alternative to use an online lab to print your larger work.

To achieve the very best results, choose a lab that provides downloadable profiles for each paper type so you can prepare your files properly. Glossy C-type paper has a gigantic color range, superior to most inkjet papers, providing richly saturated colors across most of the spectrum.

Although known primarily for color prints, the C-type is also an excellent medium for special black and white images, as shown on the facing page. Many toning and coloring effects within the subtle world of monochrome can never be effectively mixed by standard inkjet ink, but a C-type print will reproduce most delicate tones very well.

Business cards

Photo cards made by an on-demand printing service are the latest way to stylishly promote your work.

Digital photo products

Together with digital photobooks, the on-demand business card is fast becoming an emerging trend. Like ordering prints through an online photo lab, this kind of service relies on your careful preparation to get the best results.

A good service provider you'll want to try is the innovative MOO.com, shown above. MOO.com can produce a number of unusual photo products from your files, including stickers and postcards, but it is the unique letterbox mini-cards that are the most popular. The service works by digitally printing one hundred cards from your uploaded JPEG files, prepared in Photoshop Elements. However, the key benefit is that you can opt to print one hundred of the same image, or make just one card from a hundred different images (and any other combination in between!). There's no need to worry about picking out your best shot; use as many as you want.

Getting into shape first

MOO.com's unique mini-card shape, as shown above right, is far removed from the shape of a standard digital photograph, so you will need to crop each image across the top and bottom to fit. Many of your best shots may not benefit from this radical restructuring, but you will be surprised by how many average shots are improved. The service allows you to choose how many copies you want to print from each image file, as shown above, and offers the option of placing five lines of black text on the reverse side.

Like the workflow for producing on-demand photobooks, it's essential to prepare your files at 300ppi and resize them within MOO.com's downloadable template. Save copies in JPEG format and upload to the Web site when ready.

 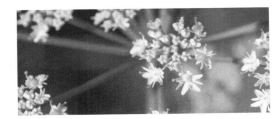

 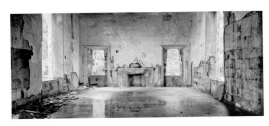

 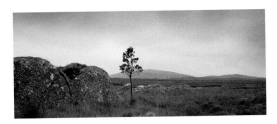

Nonprinting guides

MOO.com provides an easy-to-use template, shown right, which has predrawn guides to show you where to place your image. Anything outside the blue lines may be cut off during the print finishing process.

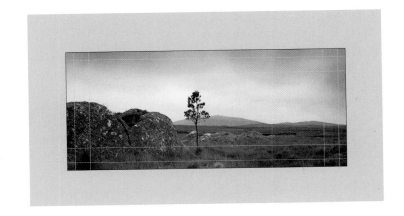

Printing with Photoshop.com

Photoshop.com is a free photo–sharing Web site where you can store, edit, and print your images.

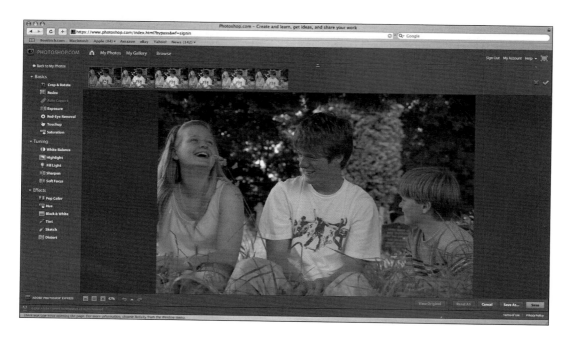

Photoshop.com benefits

The latest offering from Adobe is Photoshop.com, shown above, which is designed to help you store, edit, and share your images online. More versatile than other social networking and photo-sharing services, Photoshop.com provides a useful selection of editing tools to enhance your files. The service is available for both PC and Mac platforms, and works within a standard Web browser such as Internet Explorer and Safari. This online application is best used in full-screen mode, removing the standard browser furniture from your computer screen, so it looks and feels like a desktop program. Photoshop.com is free and offers an enormous amount of storage space—enough to accommodate around 600 high-quality JPEG files, currently the only file format accepted. The advantages of using such a service are extensive: you can store, edit, and share your work while away from your imaging workstation. After you upload your files, the images are presented all together like an index print or contact strip so you can choose which ones to work on. For location or travel photographers spending long periods away from home, this is an ideal way to manage files and even enter into some rudimentary, first-stage editing.

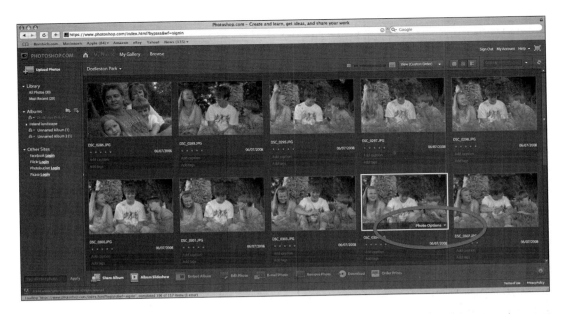

The toolbox

Unlike other online applications, Photoshop.com records your steps as you work through an editing sequence. There's no danger of overwriting the original online file, even if you issue a Save command after the edit or quit your session without reverting back to the original. This excellent feature means you can return to your image at any stage in the future and remove your previous edit with a simple click. Within the limitations of your network connection speed and your computer's processing power, the image-editing tools provide real-time previews without the need to click or slide a control bar. Most of the image-enhancing tools work by displaying a range of options (much like Elements' Variations dialog) across the top of the working window. When the cursor floats over the variation, the altered image appears immediately below, so you can see the instant effect of a range of different changes quicker than you would from a network-based source.

Printing online

Although it doesn't feature the fine-tuning tools found in Elements, Photoshop.com offers enough tricks in the box to rescue and resuscitate a flat image and prepare it for printout. When finished, you can download the file for printing at home, or deliver it directly to an online photo lab, such as Shutterfly.com, as shown above, who will return your prints in the mail.

Selling your photobooks online

You can easily sell your books to a worldwide audience using free e-commerce tools available from Blurb.com or Lulu.com.

Working out the costs

The simplest way of setting the price for your product is to start off by working out the production costs for each book. All on-demand providers publish fixed costs for books depending on their format size and binding, cover type, and number of pages. Most providers have a fee structure for books produced within a set page range, typically 1–40 pages, 41–80, and above. The price scales relate to the additional costs of binding or the use of more sheets of paper in the press, when the size of a book jumps from one range to another. There's little sense in making a 41-page book if this adds an extra 20% to the production cost for the addition of a single page, so you need to carefully consider the implications of extending your project into a higher price range. Some providers price their books by the page, a more flexible arrangement, but one that makes it easy to overlook the cumulative costs.

Setting the retail price

The beauty of using e-commerce to distribute and sell your books is that you can set the price to match the demand. Start by figuring out your production costs first and then work out how much you could sell the book for. Deduct from this the percentage taken in commission by the provider and you can determine how much profit you can make on each sale.

Using a virtual shopfront

One of the better online sellers and printers, Blurb.com offers plenty of tools to help you get your project off the ground. Blurb also has an effectively organized shopfront, called the Bookstore, where your books appear ready for sale once they have been uploaded. The Bookstore is arranged in different categories, such as Fine Art, Travel, and Photography, and your work is placed in the correct section, just as in a conventional bookstore. The Web site also offers tools for users to administer their projects, contact details, and royalty payments. As with most other online sellers, you can easily track the number of copies sold by logging into your unique admin area.

Promoting and previewing your book

Like all Web-based selling, accurate keywording will enable potential buyers to retrieve your book easily in a search. The trick with keywording is to think laterally about your book, or better still, ask others to think of potential descriptors. Blurb creates an automatic page-flip preview of the first 15 pages of your book, as shown opposite. The benefits of providing a preview are clear: potential buyers can see the contents pages, some sample spreads, and, of course, the quality of your work. With this in mind, it would be sensible to pack these first 15 pages with tempting content, so any potential customer is left in no doubt as to the quality of your book.

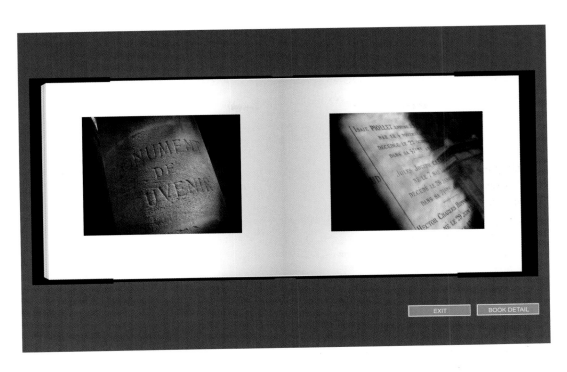

EXIT BOOK DETAIL

EXIT BOOK DETAIL

Reference

Suppliers

Further information on any of the products featured in this book is available from the following Web sites:

Computer workstations
www.apple.com
www.dell.com

External storage drives
www.lacie.com
www.drobo.com
www.iomega.com
www.westerndigital.com

Computer monitors and tablets
www.samsung.com
www.lacie.com
www.nec.com
www.eizophoto.com
www.apple.com
www.wacom.com

Color calibration equipment
www.xrite.com
www.datacolor.com
www.lacie.com

Image-editing software
www.adobe.com
www.ononesoftware.com
www.niksoftware.com
www.flamingpear.com
www.autofx.com
www.alienskin.com

Digital cameras
www.nikon.com
www.canon.com
www.olympus.com
www.sony.com
www.leica.com
www.fujifilm.com
www.panasonic.com
www.hasselbladusa.com
www.pentax.com
www.leafamerica.com

Digital camera memory cards
www.lexar.com
www.sandisk.com
www.delkin.com

Camera bags and luggage
www.tenba.com
www.lowepro.com
www.crumpler.com
www.billingham.co.uk

Photobook services
www.blurb.com
www.lulu.com
www.pikto.com
www.yophoto.co.uk
www.bobbooks.co.uk
www.asukabook.com
www.whcc.com
www.artefactstudio.com
www.photobookpress.com

Inkjet printers

www.epson.com
www.canon.com
www.hp.com

Portable printers

www.sony.com
www.canon.com
www.polaroid.com
www.zink.com

Photo-sharing communities

www.photoshop.com
www.flickr.com
www.picasa.google.com
www.smugmug.com
www.photobox.co.uk
www.livebooks.com

Royalty-free image libraries

www.istockphoto.com
www.alamy.com

Tripods

www.gitzo.com
www.manfrotto.com

Photography retailers

www.calumetphoto.com
www.fotocare.com
www.bhphotovideo.com

Presentation and portfolios

www.lost-luggage.com
www.houseofportfolios.com
www.modernpostcard.com

Paper and printing media

www.epson.com
www.moabpaper.com
www.inkpress.com
www.canson.com
www.hahnemuehle.com
www.inveresk.co.uk
www.permajet.co.uk
www.breathingcolor.com
www.harman-inkjet.com
www.ilford.com
www.lyson.com
www.inkjetmall.com
www.kodak.com

Liquid inkjet coating

www.inkaid.com

Archival storage systems

www.dickblick.com

Mount cutting and framing

www.dickblick.com
www.framersisland.com
www.logangraphic.com

Photography workshops

www.rmsp.com
www.theworkshops.com
www.santafeworkshops.com

Large format output

www.terajet.com
www.inkjetoutput.com

Troubleshooting

When prints don't turn out as you expect, it's usually caused by a simple inkflow issue or processing error.

Black ink run out

Yellow ink run out

Excessive JPEG compression

Over-enlarged file

Magenta ink run out

Cyan ink run out

Over-sharpened

Unsharpened

Glossary

Artifacts

By-products of digital processing such as noise and JPEG compression, both of which will degrade image quality.

Aliasing

Square pixels can't depict curved shape,s and when viewed in close-up they look like a staircase. Anti-aliasing filters, found between the camera lens and image sensor, lessen the effects of aliasing by reducing contrast, which has to be reinstated during image processing.

Bit

A bit is the smallest chunk of digital data, which can express two states. such as on or off, or if used to describe color, black or white.

Bitmap

All digital images are made from pixels arranged in a chessboard-like grid called a bitmap.

Byte

A byte is eight bits of digital data, expressing 256 different states or colors.

CCD

Stands for Charged Coupled Device. It is the light sensitive "eye" of a scanner and "film" in a digital camera.

Clipping

Clipping occurs when image tone close to highlight and shadow is converted to pure white or black during scanning or exposure in-camera.

CMYK image mode

Stands for Cyan, Magenta, Yellow, and Black (called K so it is not confused with blue). It is an image mode used for litho reproduction. All magazines are printed with CMYK inks.

Color space

RGB, CMYK, and LAB are three different kinds of color spaces, each with a unique characteristic palette, but also limitations in terms of color reproduction.

Compression

Crunching digital data into smaller files is known as compression. Without physically reducing the pixel dimensions of an image, compression routines work by creating a smaller string of instructions to describe groups of pixels, rather than individual ones.

Curves

Curves are a versatile tool for adjusting contrast, color, and brightness by pulling or pushing a line from highlight to shadow.

Dithering

A method of simulating complex colors or tones of gray using few color ingredients. Close together, dots of ink can give the illusion of new color.

Dropper tools

Pipette-like icons that allow you to define color selection and tonal limits, such as highlights and shadows, by directly clicking on parts of the image.

Dye sublimation

A kind of digital printer that uses a CMYK color-infused dry ink sheet to pass color onto special printing paper.

DPOF

Digital Print Order Format is a set of universal standards allowing you to specify print-out options directly from a camera when connected to direct printing units such as Epson's PictureMate range.

Duotone

A duotone image is made from two different color channels chosen from the color picker. This technique is used to create subtly toned, monochromatic images.

Driver

A small software application that instructs a computer to operate an external peripheral device like a printer or scanner. Drivers are frequently updated but are usually available as a free download.

Dynamic range

The measure of the brightness range in photographic materials and digital sensing devices. The higher the number, the greater the range. Professional scanners and media are able to display a full range from white to the deepest black.

File extension

The three- or four-letter/number code that appears at the end of a document name, preceded by a full stop—for example, landscape.tif. Extensions enable applications to identify file formats and enable cross-platform file transfer.

File format

Images can be created and saved in many different file formats, such as JPEG, TIFF, or PSD. Formats are designed to let you package images for purposes such as email, printout, and Web use.

Firewire

A fast data transfer system for high-resolution image files. Also known as IEEE1394.

Gamma

The contrast of the midtone areas in a digital image.

Gamut

Gamut is a description of the extent, or range, of a color palette used for the creation, display, or output of a digital image.

Grayscale

Grayscale mode is used to save black-and-white images. There are 256 steps from black to white in a grayscale image, just enough to prevent the appearance of banding to the human eye.

Highlight

The brightest part of an image, represented by 255 on a 0–255 scale.

High resolution

High-res images are generally made with a million or more pixels and are used to make high-quality printouts.

Histogram

A graph that displays the range of tones present in a digital image as a series of vertical columns.

Glossary (continued)

ICC

The International Color Consortium was founded by major manufacturers to develop color standards and cross-platform systems.

Interpolation

All digital images can be enlarged, or interpolated, by introducing new pixels to the bitmap grid. Interpolated images never have the same sharp quality or color accuracy of originals.

JPEG

JPEG is an acronym for Joint Photographic Experts Group and it is a universal file format used for compressing images. Most digital cameras save images as JPEG files to make more efficient use of memory cards.

Levels

A common set of tools for controlling image brightness found in Adobe Photoshop Elements and many other imaging applications. Levels can be used for setting highlight and shadow points and for correcting camera exposure errors.

Low resolution

Low-res images are small in size, produce poor-quality printouts, and are only suitable for Web page display.

Megapixel

Megapixel is a measurement of how many pixels a digital camera can make. A bitmap image measuring 1800×1200 pixels contains 2.1 million pixels, made by a 2.1 megapixel camera.

Optical resolution

Sometimes called true resolution, this refers to the uninterpolated pixel dimensions of an image.

Pigment inks

A more lightfast inkset for inkjet printers, usually with a smaller color gamut than dye-based inksets. Used for producing prints for sale.

Pixel

Taken from the words PICture ELement, a pixel is the building block of a digital image, like a single tile in a mosaic. Pixels are generally square in shape.

Pixellation

When a digital print is made from a low-res image, fine details appear blocky or pixellated because not enough pixels were used to describde complex shapes.

Plug-in

A plug-in is a piece of software that adds extra functions to your favorite application—like Adobe Photoshop.

Profile

The color reproduction characteristics of an input or output device. This is used by color management software to maintain color accuracy when moving images across computers and input/output devices.

RAM

Random Access Memory is the part of your computer that stores data during work in progress, helping you run applications and keep large images open.

RAW

A generic term for the file formats produced by different digital cameras, which retain flexibility in some shooting parameters.

RGB image mode

Red, Green, and Blue mode is used for color images. Each separate color has its own channel of 256 steps, and pixel color is derived from a mixture of these three ingredients.

RIP

A Raster Image Processor translates vector graphics into bitmaps for digital output. RIPs can be both hardware and software and are used on large-format printers to maximize the use of consumables.

Selection

A fenced-off area created in an imaging application like Photoshop, which limits the effects of processing or manipulation.

Shadow

The darkest part of an image, represented by 0 on the 0–255 scale.

Sharpening

A processing filter that increases contrast between pixels to give the impression of greater image sharpness.

TFT monitor

A Thin Film Transistor monitor is the flat-panel type of computer screen.

TIFF

Tagged Image File Format. A format that is the most widely used by professionals, as it is compatible with both Macs and PCs. A layered variation also exists, but this is less compatible.

Unsharp mask (USM)

This is the most sophisticated sharpening filter found in many applications.

USB

Stands for Universal Serial Bus. This is a type of connector that allows for easier setup of peripheral devices.

White balance

Digital cameras can counteract the effects of color casts caused by artificial light with a white balance function.

White-out

In digital images, excessive light or overexposure causes white-out. Unlike film, where detail can be coaxed out of overexposed negatives with careful printing, white pixels can never be modified to produce lurking detail.

Index

Credits

Further information

Tim Daly is Senior Lecturer at the University of Chester in the UK, and teaches digital printing workshops in the UK, Ireland, and at the Rocky Mountain School of Photography in Montana.

Tim also writes for many photography magazines, including *Photo-District News (PDN)*, *The British Journal of Photography*, *AG: The International Journal of Photographic Art and Practice*, *Outdoor Photography*, *Black and White Photography*, and *Better Photoshop Techniques (Aus)*.

Tim also runs Photocollege, the online learning resource center, which can be found at www.photocollege.co.uk. You can contact him by email at timdaly@photocollege.co.uk, or through his website: www.timdaly.com.

Pictures

All photographic and illustrative images reproduced in this book are copyright Tim Daly.

Product images are reproduced courtesy of the following: Apple, Dell, Nikon, Tenba, Lyson, Adobe, Manfrotto, X-Rite, Epson, Canon, Polaroid, Moab, Breathing Color, Harman, Blurb.com, Lulu.com